"More Choices. More Rates. Your Best Mortgage."

 FIRST COMMUNITY MORTGAGE

Scott D. Seaman
MORTGAGE LOAN CONSULTANT

121 South Tejon St., Ste. 201
Colorado Springs, Colorado 80903
Tel: **719.448.4462** Fax: **719.448.4497**
Free: **877.403.7666**
Email: **sseaman@fcbcolo.com**
APPLY ONLINE: **www.scottseaman.com**

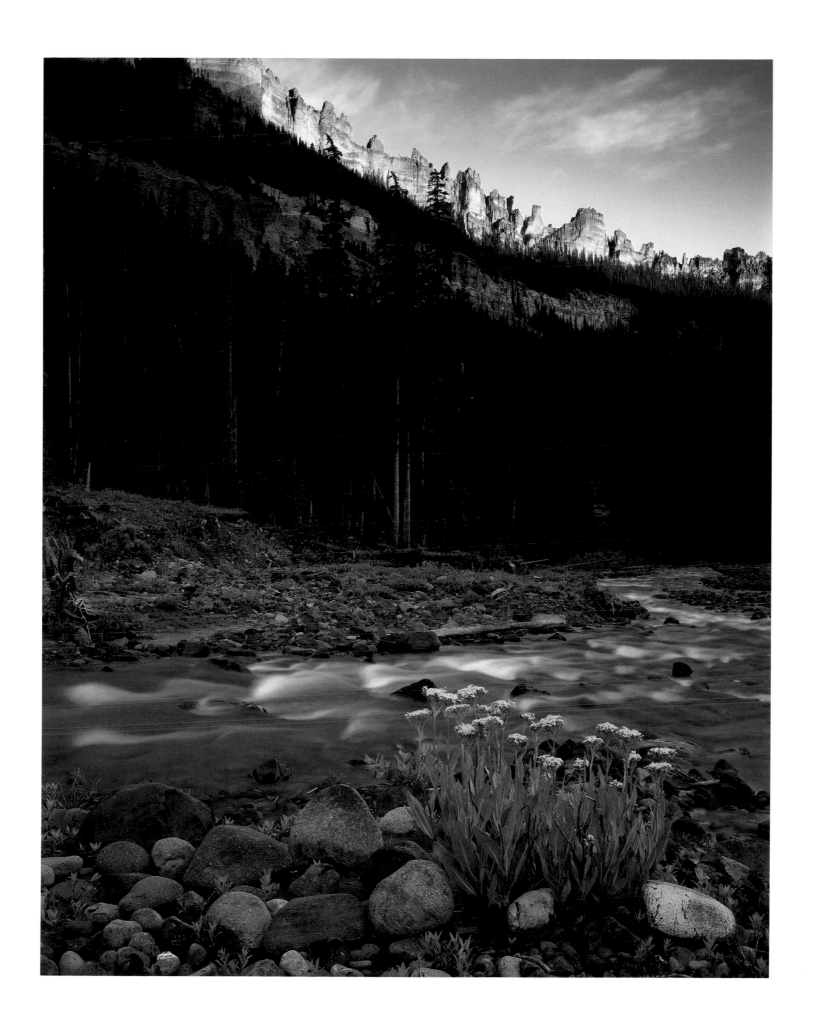

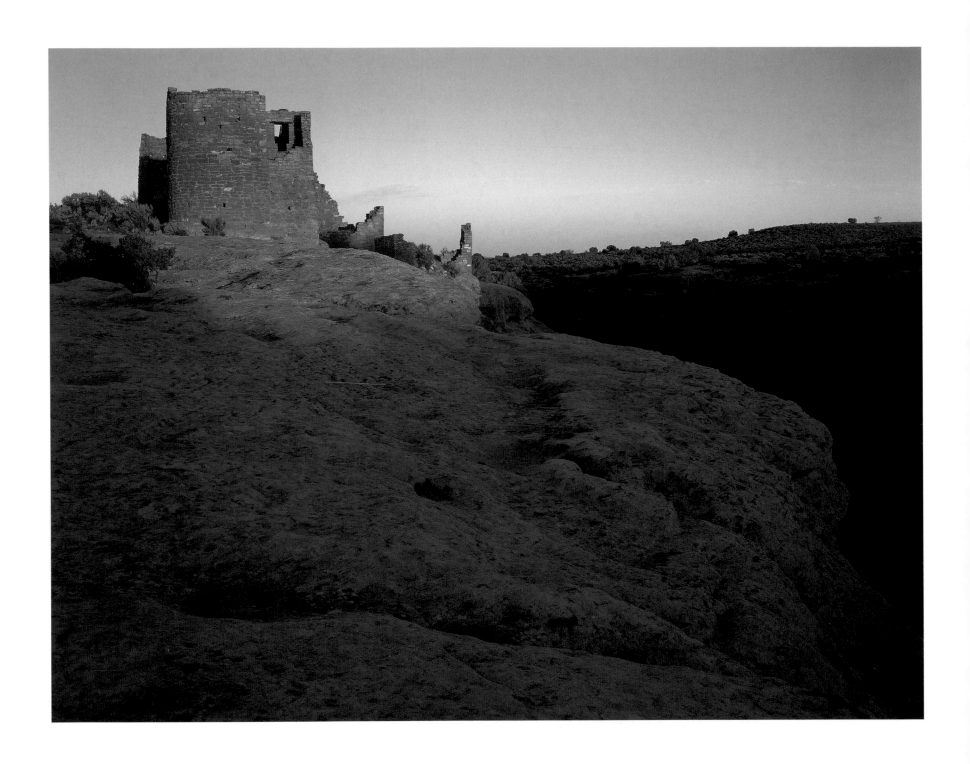

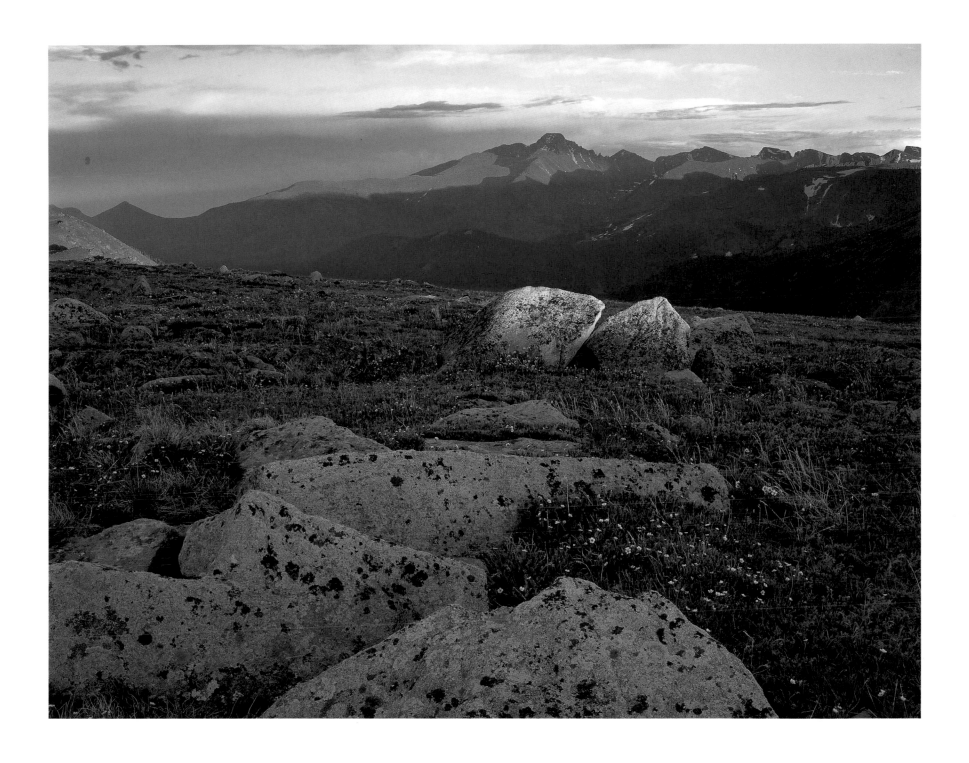

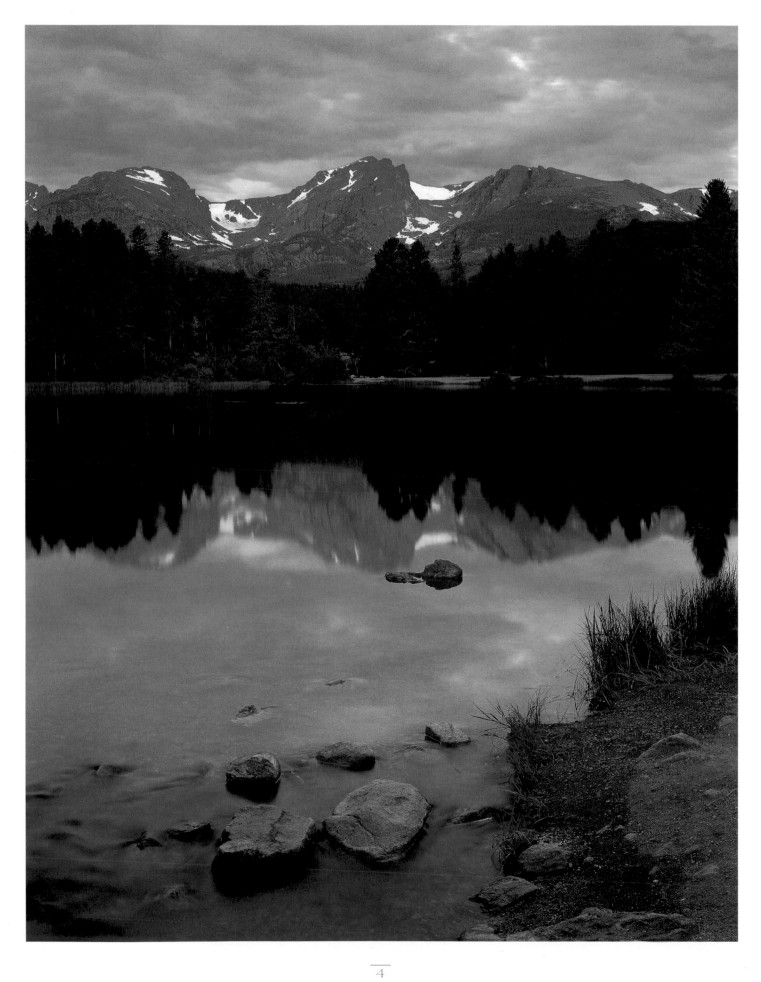

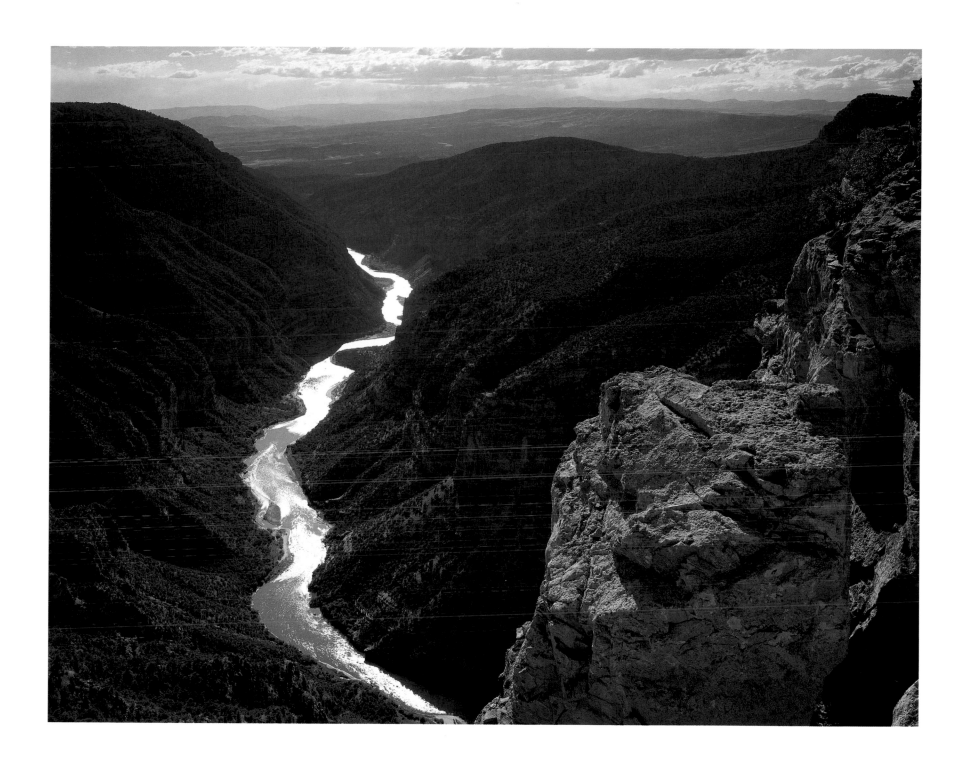

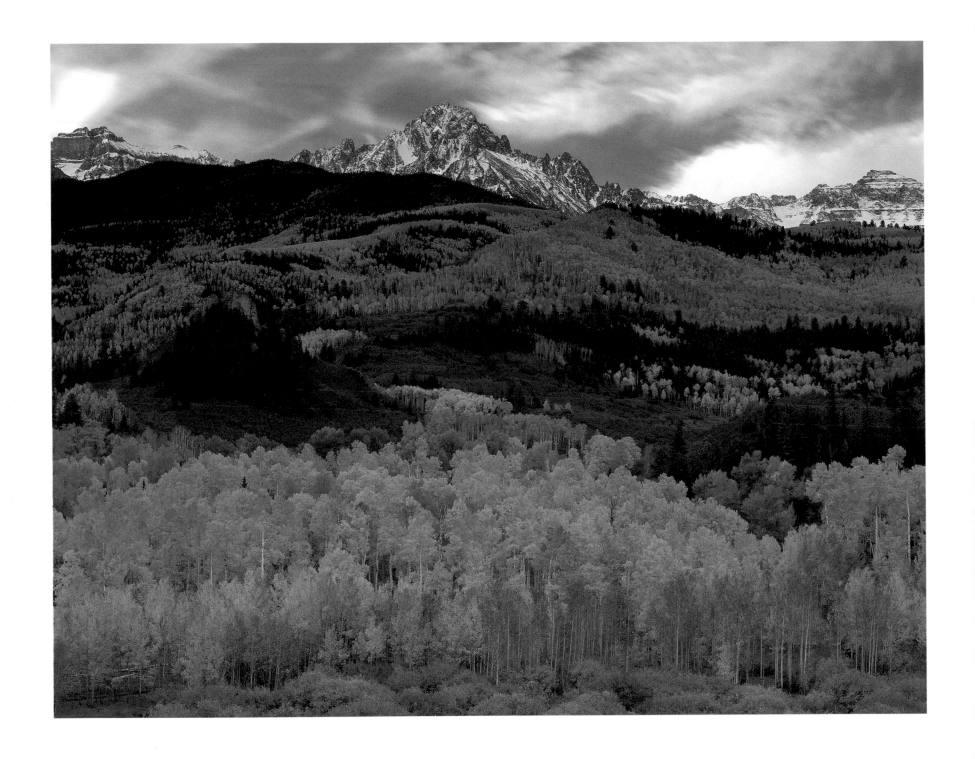

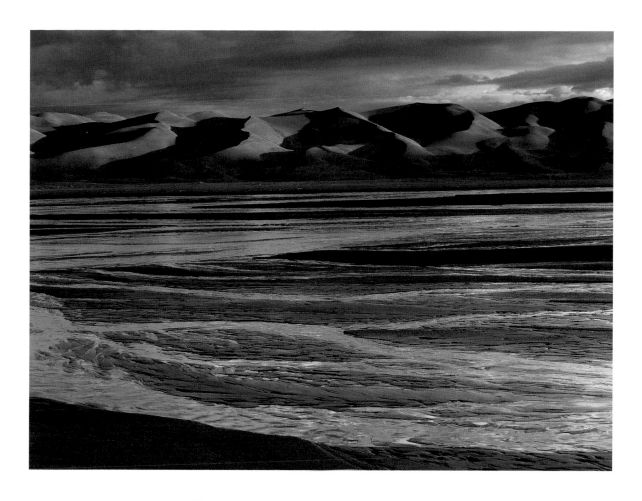

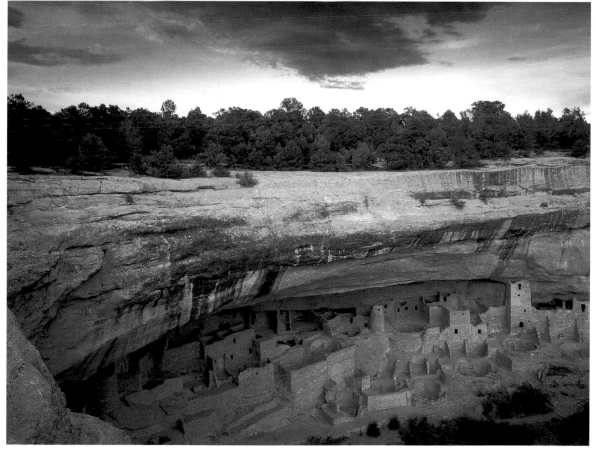

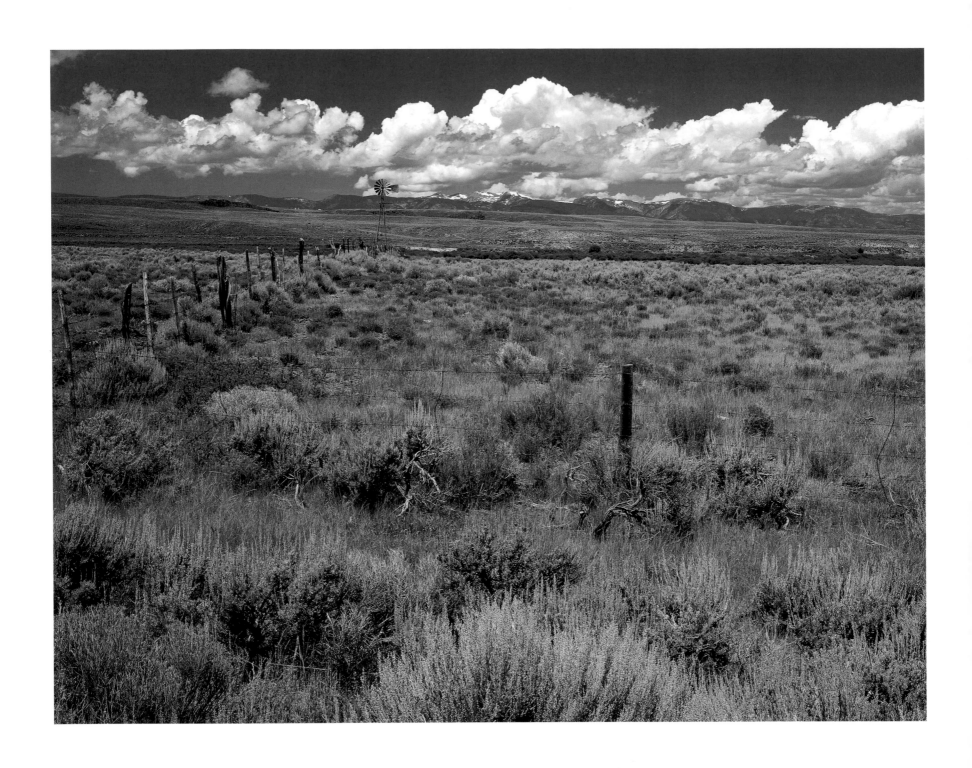

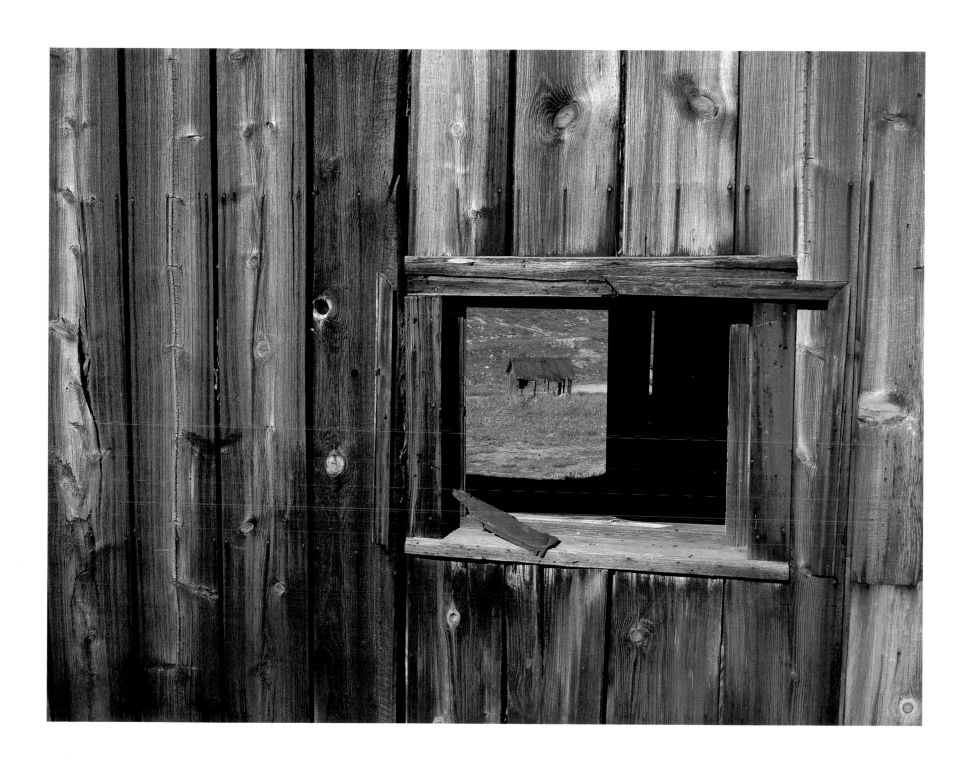

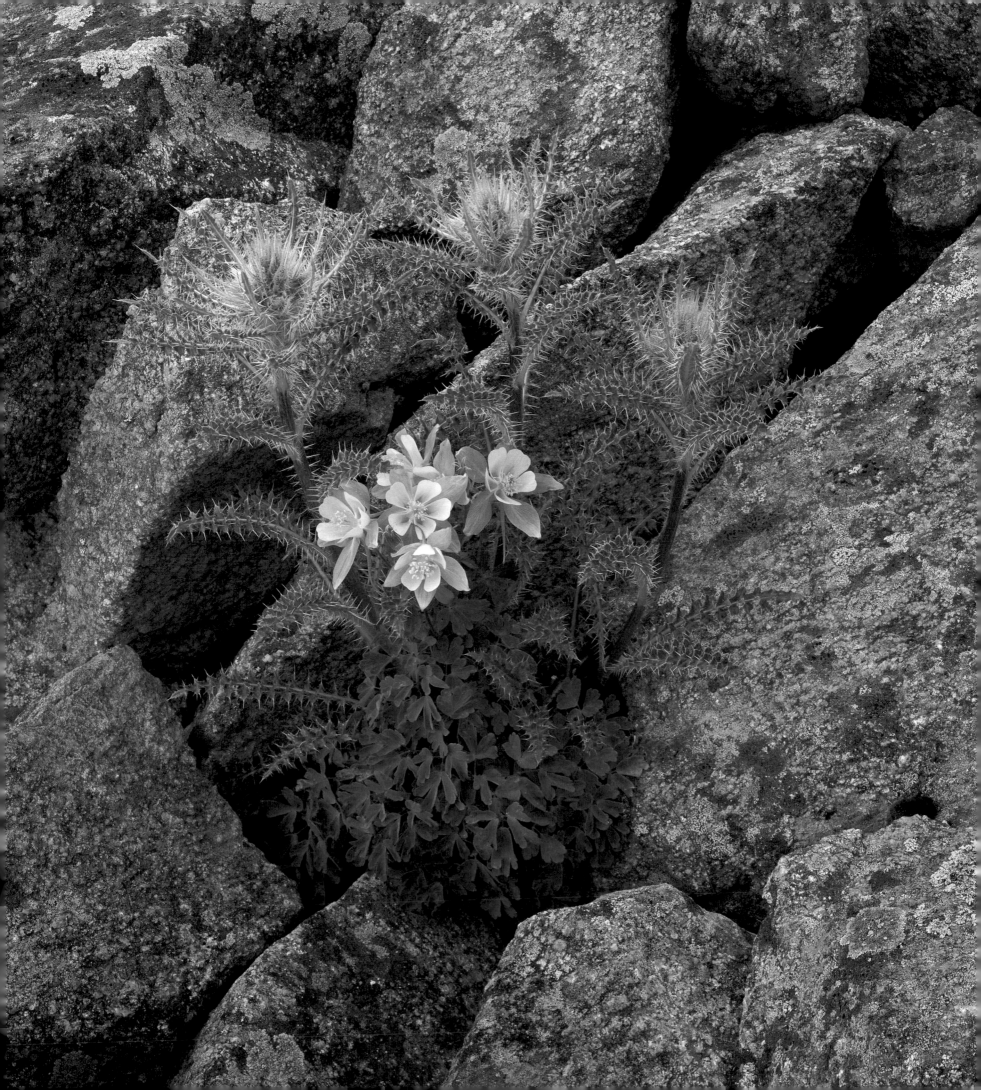

COLORADO WILD

Preserving the Spirit and Beauty of Our Land

Text by Judith B. Sellers
Photography by Willard Clay
Foreword by T. A. Barron

Voyageur Press

Edited by Michael Dregni
Designed by Andrea Rud
Printed in Hong Kong

04 05 06 5 4 3 2

Library of Congress Cataloging-in-Publication Data
Sellers, Judith B.
 Colorado wild : preserving the spirit and beauty of our land / text by Judith B. Sellers ; photography by Willard Clay ; foreword by T. A. Barron.
 p. cm.
Includes bibliographical references and index.
 ISBN 0-89658-504-2 (hardcover)
 1. Natural history—Colorado. 2. Natural history—Colorado—Pictorial works. 3. Nature conservation—Colorado.
I. Title.
 QH105.C6 S435 2002
 508.788—dc21
 2002002603

Distributed in Canada by Raincoast Books,
9050 Shaughnessy Street, Vancouver, B.C. V6P 6E5

Published by Voyageur Press, Inc.
123 North Second Street, P.O. Box 338,
Stillwater, MN 55082 U.S.A.
651-430-2210, fax 651-430-2211
books@voyageurpress.com
www.voyageurpress.com

ON PAGE 1: Sunrise on the Cock's Comb above the Middle Fork of the Cimarron River in the Uncompahgre National Forest.

ON PAGE 2: The sun highlights Hovenweep Castle at Hovenweep National Monument.

ON PAGE 3: Sunlight crowns Longs Peak in Rocky Mountain National Park.

ON PAGE 4: Sunrise lights Hallett Peak above Sprague Lake in Rocky Mountain National Park.

ON PAGE 5: The waters of the Green River mirror the sun's light in Whirlpool Canyon, Dinosaur National Monument.

ON PAGE 6: Autumn aspens glow below Mount Sneffels in the San Juan Range, Uncompahgre National Forest.

ON PAGE 7, TOP: Sunlight and shadows on the sand dunes and Medano Creek in the Great Sand Dunes National Park and Preserve.

ON PAGE 7, BOTTOM: Daylight finds the Cliff Palace at Mesa Verde National Park. (Dennis Flaherty)

ON PAGE 8: Sagebrush basks in the sun near Walden in Jackson County.

ON PAGE 9: Ghost town buildings at Animas Forks in the San Juan Mountains.

ON PAGE 10: Columbine flower amidst thistles and rocks in the tundra of the Collegiate Peaks Wilderness in San Isabel National Forest.

DEDICATION

To my father, John Spurgeon Bagwell, who, long ago, opened my eyes and heart to the magic of the natural world.
—Judith Sellers

To Debra Alsvig-Clay for her continued support and encouragement.
—Willard Clay

ACKNOWLEDGMENTS

No book comes to fruition without the help, time, support, and inspiration of many people. We are indebted to naturalist author Ann Zwinger, the mischievous matchmaker who initially put us in touch with each other, believed in us, and offered much encouragement and insight along the way. And to Tom Barron, with whom I have shared many a golden moment under the Colorado sky, for his gracious foreword to the book.

It has been a pleasure to work with Michael Dregni of Voyageur Press on this project. His vision, professionalism, and commitment pushed us to go further and kept us honest and on track.

Our deep appreciation to the dedicated personnel in the National Parks Service, the National Forest Service, and the many conservation organizations throughout the state, without whose help this book would never have come together.

Judy would also like to thank the countless friends and family with whom I have spent precious moments in the outdoors, especially John Sellers, my patient climbing partner; The Wandering Ewes, my hiking buddies; Julie Farrell for a glorious day among the dinosaurs; Scott Sellers for his much needed and invaluable technical support; Rob Bleiberg of The Mesa Land Trust for a defining day on the Colorado Plateau; Audrey Benedict for reading and ably critiquing the manuscript; Pam Munro, curator of the Francisco Fort Museum; Chris Pague and Melinda Helmick of the Colorado Chapter of The Nature Conservancy; Doug Robotham, Colorado Field Office of The Trust for Public Lands; Sydney Macy, Western Office of The Conservation Fund; Aimee Cox, El Paso County Parks. And, most importantly, my husband Buz, for his unfailing patience along the way.

Will wishes to express his appreciation to Duke Phillips of the Chico Basin Ranch; J. C. Leacock, John Botkin, and Joe Arnold for their personal support and hospitality.

CONTENTS

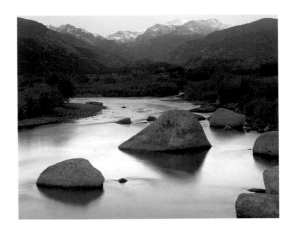 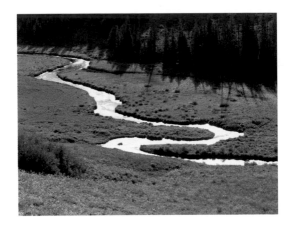

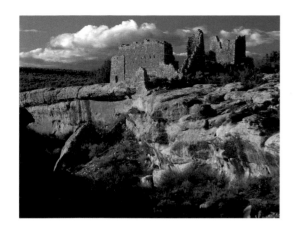 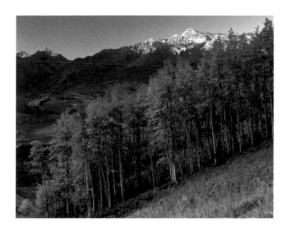

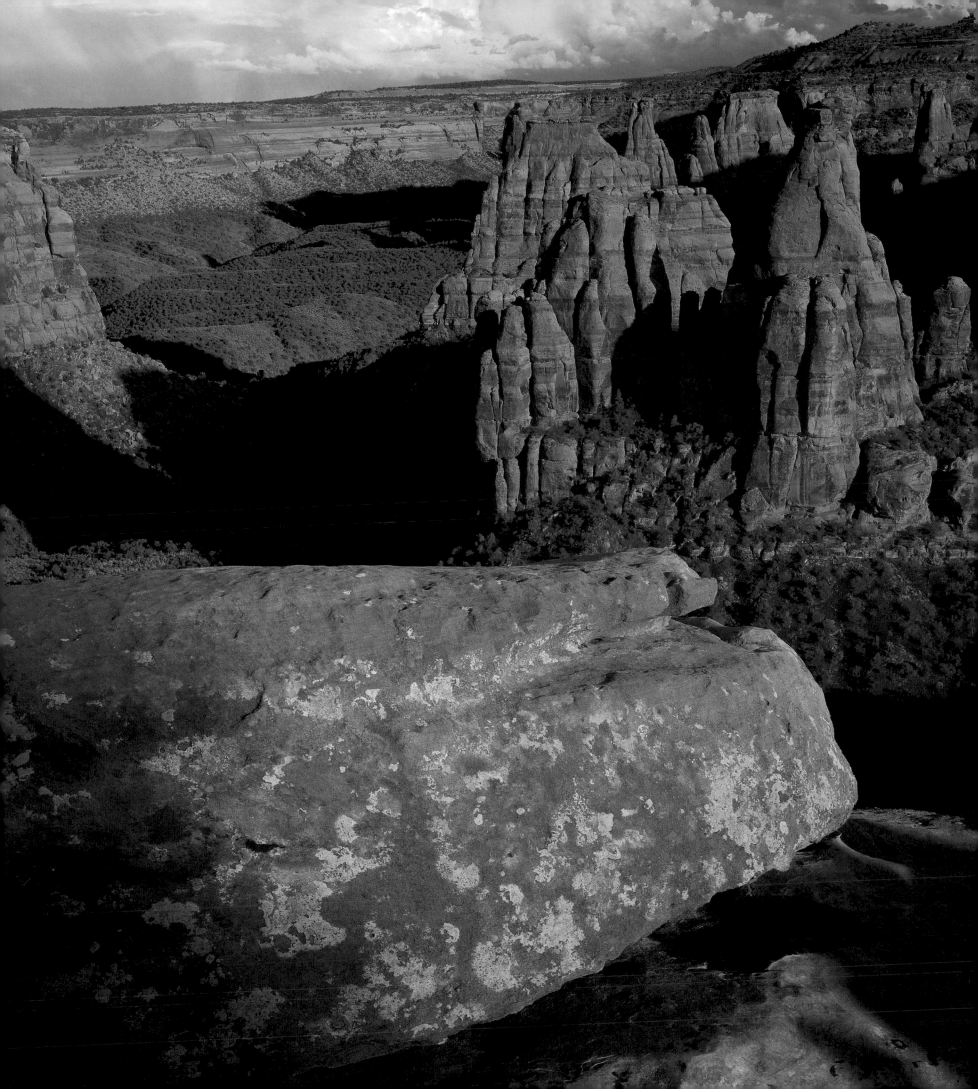

FOREWORD

by T. A. Barron

T. A. Barron is a longtime Colorado resident and author of many books. Among his nature books are *Rocky Mountain National Park: A 100 Year Perspective* and *To Walk in Wilderness: A Rocky Mountain Journal*. He is also the author of the five-book series *The Lost Years of Merlin* and the children's book *Where is Grandpa?*

What you are holding in your hands is not a book. No, it's a journey—a full-blown expedition through the meadows, marshes, canyons, summits, prairies, ridges, ancient human dwellings, and even-more-ancient dinosaur footprints of Colorado.

And what a journey! Judy Sellers's friendly eloquence combines with her passion for this remarkable place to produce text as bright and sparkling as the mountain air itself. When she trains her observant eyes on the briefest moments, the tiniest details, we are right there. Her words become our hiking boots, carrying us deep into the land. She enables us to view each element of Colorado with supreme clarity—as if the whole state were a glowing, multifaceted crystal we can hold in our hands.

What's more, Willard Clay's photographs truly bring the landscape to life. His pictures display all the subtlety and variety of the Colorado countryside. And something else, as well: the play of light, in all its moods, on places as diverse as a misty alpine tarn, a colorful canyon, and a sunlit aspen grove.

This journey is more than visual, however. Thanks to these exquisite words and pictures, we can see beneath the surface of Colorado's land, experiencing its many wonders and mysteries. We feel the flow of geologic time—as we imagine great mountains rising over eons only to be crushed under tons of ice or carried out to sea one pebble at a time. We feel the enormity of space—as we stand dwarfed by huge ridges and vast prairies that are themselves dwarfed by the blue sky above. We feel, in our bones, the endless rhythm of wilderness—as we listen to a living heart that echoes our own.

We feel the spirit of the land.

As we embark on our journey, let's remember that Colorado—the state that inspired the song "America the Beautiful"—is just as fragile as it is magnificent. It is our gift from God to enjoy, and also our challenge to conserve. We can treasure it, grow wiser and stronger from it, and pass it on to our children. Or we can treat it merely as a game board where people get to play, with no thought of the future, and devour it in the process. It's our land—and our choice.

Colorado, with all its wonders, lies before you. Enjoy the journey!

T. A. Barron

AN AFTERNOON STORM CLEARS OVER MONUMENT CANYON IN COLORADO NATIONAL MONUMENT.

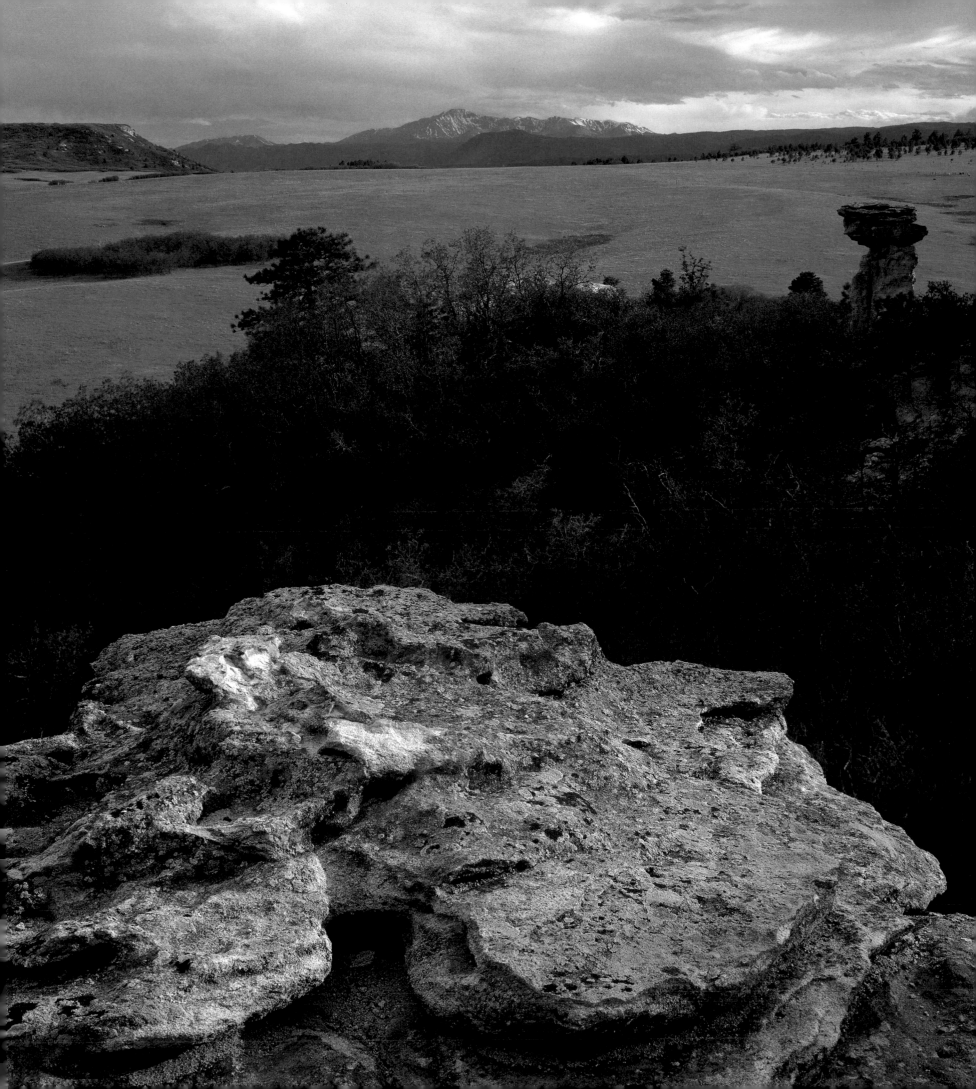

"And this, our life, exempt from public haunt, finds tongues in trees, books in the running brooks, sermons in the stones, and good in everything."
—William Shakespeare, *As You Like It*

A BOUNTIFUL LAND

To the casual observer, Colorado is synonymous with snow-covered peaks, breathtaking vistas, sparkling mountain streams, and bountiful wildflower meadows. Those who are well acquainted with the state know there is much more: pronghorn skimming over the plains, dinosaur-track fossils in windswept sandstone canyons, Sahara-like sand dunes against a backdrop of 14,000-foot peaks, fantastical rock outcroppings, enormous prairie skies, and twisting, narrow canyons etched by wind and water.

Colorado stands at a topographical crossroads, borrowing landforms from each of its surrounding states to create a geologic diversity found in few other regions. Its eastern edge marks the end of the Great Plains whereas the western part of the state contains a chunk of the Colorado Plateau, the magnificent canyon country of Utah and Nevada. The Southern Rocky Mountains command the center of the state, piercing the sky on a north-south axis between the Wyoming and New Mexico borders.

Colorado owes the rich kaleidoscope of its landscape, quite simply, to the continuing uplift of its mountains, both the present ones and those that vanished long ago. To put Colorado's altitude in perspective, the lowest spot in the state—close to the Kansas border—is higher than most of the mountains in the Eastern Appalachian range, an astonishing comparison, especially for those who grew up along the Atlantic seaboard.

The rise of the ancestral Rockies occurred more than 300 million years ago, possibly as a result of the collision of the North and South American continents. Then, gradually, imperceptibly, wind and a changing climate that melted the glaciers encasing the peaks wore this early range away. Torrential floods raged down from the glaciers, bearing enormous loads of sand and gravel eastward and carving out valleys and intricate canyons. These recycled, relocated mountains make up the prairie land that we walk on today.

A secondary uplift beginning some 70 million years ago created the striking peaks that define Colorado today, among them Mount Elbert, the third-highest peak in the continental United States at 14,433 feet; the rugged, awesomely beautiful San Juan mountain range to the southwest; and Pikes Peak, which forms the backdrop for Colorado Springs and was the inspiration for Katherine Lee Bates's anthem "America the Beautiful."

The human history of Colorado is as multi-faceted as its scenery: Native Americans, their culture an echo of the land itself and intrinsically tied to it, hard-driving cattlemen, gold miners, Basque sheepherders, Spanish conquistadors searching for the elusive City of Gold, and rough-hewn mountain men. They came searching—for a new beginning, for fortunes to be made, or perhaps for something undefined within themselves. The relics of those early days can be seen everywhere: a roofless log cabin along a rocky trail high above

ROCK OUTCROPPINGS AND ROLLING HILLS OF THE GREENLAND RANCH NEAR CASTLE ROCK IN DOUGLAS COUNTY LEAD UP TO PIKES PEAK IN THE FAR DISTANCE.

timberline, abandoned mine shafts, the lonely grave of a newborn in a mountain meadow, the windswept grasslands on the eastern plains where the shameful massacre of helpless Indian women and children at the hands of a misguided militia took place. The Native Americans left their mark as well, in the Anasazi ruins at Mesa Verde, in countless etchings on canyon walls, and in place names around the state. Cochetopa Pass ("Pass of the Buffalo"), Huajatolla Peaks ("Breasts of the Earth"), the towns of Ouray and Chipeta Park (named after the great Ute chief and his wife), and the Chinook ("Snow Eater") winds of early spring are all Indian words.

The lives and fortunes of these first settlers were shaped by the land. Hardships came with the territory, and a high price was paid. Physically and emotionally it exacted its toll. But I wonder, did this magnificent country that exacted so much give anything back as well? Did these newcomers have time and spirit to appreciate such a magnificent landscape? Did they stand in awe, as I have, gazing up at the soaring 14,000-foot peaks? Did they gain renewal and spiritual sustenance, as have I, from such grandeur? Did the miner, plodding up steep slopes to his inadequate cabin, respond to the grandeur that lay all around him? Or was life too mean, the loneliness too overpowering, the fear of failure too close to value the astonishing beauty of the land in which they lived?

The fierceness of the landscape can be overwhelming. A capricious hailstorm destroys a farmer's hard-earned crops in minutes; a spring blizzard brings death to newborn calves on the unforgiving prairie and to travelers on the interstate. A fast-moving lightning storm above timberline elicits sheer terror from hikers, who moments before had basked in the unspoiled tranquility and beauty of the landscape.

Colorado breeds a toughness in all its inhabitants. A spirit and a tenacity as tough as the ptarmigan that winters above tree line in the land of snow, its legs and feet bundled in feathery overshoes. As tough as the pasque flower, the first sign of spring in the foothills, poking up through snowdrifts left by a late-winter storm. As tough as the limber pine that wraps itself stubbornly around exposed rock outcroppings, defying the blustering Chinook winds of early spring.

The enormity of the landscape can also be overwhelming. But look more closely, take more time. In that vast sweep of prairie lie the tiny eggs of the mountain plover. Stand still and listen to the clarion song of the meadowlark, and the rustle of delicate seeds of grass— dainty wisps in the wind. Look down from the mountaintops—not at the sweeping panorama that stretches before you but at the tiny world beneath your feet. At the alpine forget-me-nots, the most intense blue I have ever seen; at the lichen clinging to bits of granite rock, in hues of orange, lime green, and black; at the elfin-sized rock jasmine, miniature pearls tossed upon the ground.

The landforms that make up the state are laid out like streams of ribbons, parallel lines running north and south. Moving from east to west, one progresses from the subtle beauty of the eastern prairie, gently upward through the gateways leading to the high country,

across the mountains, and down the western slope to the austere plateau and canyon country that transition into the desert regions of Utah and Nevada.

What is the spirit of the land? The answers lie within each of us, taking root as we wander, as we stop to look more closely, as we wonder and learn more about this amazing landscape around us. It is experienced in the fresh fall of snow, in the echoing call of geese flying overhead, in the first snow buttercups pushing up through the snow at timberline.

Take time to explore the richness of the Colorado landscape beyond what pen and camera can tell. Lie down in a grassy meadow above timberline. Hear the echo of a raven's wings against canyon walls, the bugling of elk during the fall season of rut, the howl of a coyote far off in sage country. Feel the sting of driven snow against your face, poke your toes in the chill of a mountain stream, and listen for a marmot's shrill whistle when you venture into its neighborhood.

Take a walk at sunset to see the sun go down; watch the deer come out to feed, and the moon rise over the prairie. Then, later, when the moon has set, look up to the blackness of the sky and the innumerable stars that appear with such clarity in our high, clear air. Stand high on a ridge above a river canyon and feel the force of the wind as it carves and etches the rock below.

This diversity that lies within the state can never be wholly captured, absorbed, or experienced. Having lived in Colorado for more than thirty years with much time spent in exploring its bountiful landscape, I know too well that I have only begun to scratch the surface.

Biologist Edward Wilson writes about mankind's innate, instinctive connection with the natural world, about our need for a restoration and spirituality that can only be acquired by an intimate association with the land. This oneness, he postulates, is the essential centering, the wellspring from which our fundamental goodness is generated. He warns, however, that this connection is disappearing as we become more urbanized and less sensitized to the natural landscape, and that with this deprivation, much is lost within each of us as well.

So this book is an invitation to residents, to visitors, to armchair travelers—to all who seek value in the natural landscape and who rely on its grace. It is only a beginning of all there is to see and do, *un amuse-gueule*, as the French say, a literary "tasting," an overview, to whet your appetite, to tempt you to seek further. There is so much more to know—to feel the crunch of snow beneath your boots, to hear the call of the chickadee, to watch a pika industriously piling up dried grasses for winter foraging. . . .

This book is also an interpretation created by the images of Willard Clay and the weaving together of my words. The final interpretation, however, lies within each of you as you, like we, explore this extraordinary region and as you search for your own spirit of the land.

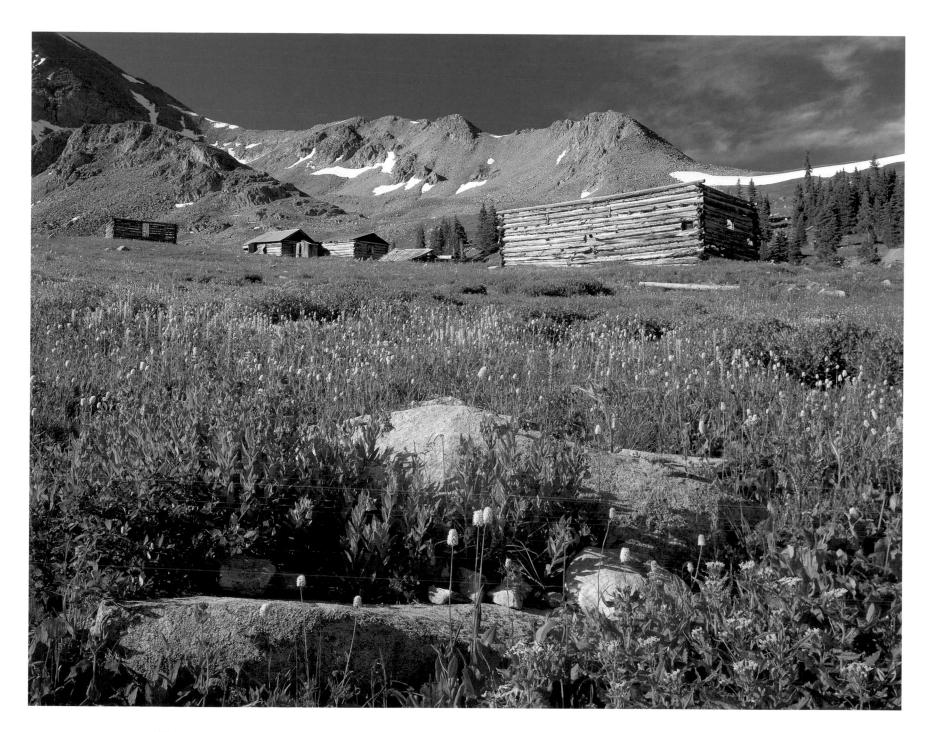

Wildflowers take over the ghost town of Boston in the Tenmile Range's Mayflower Gulch.

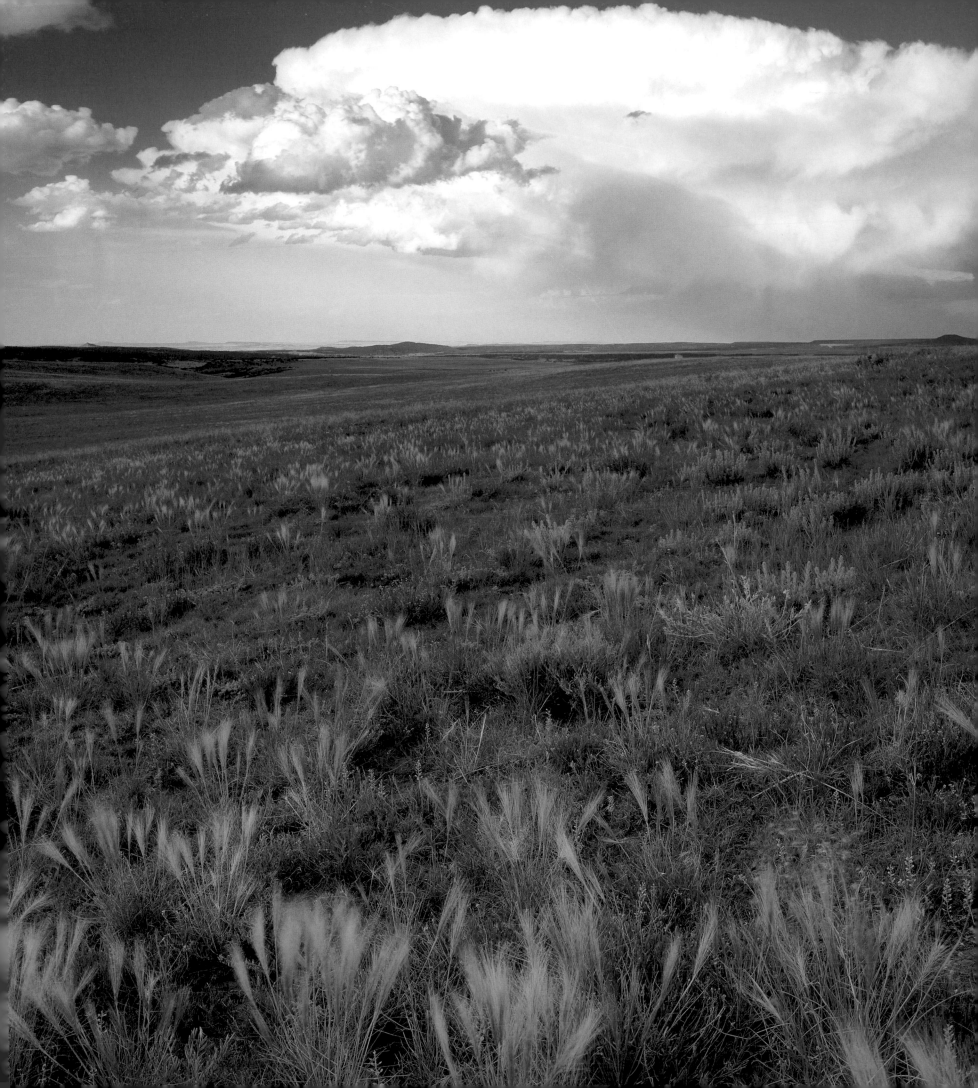

"I was born upon the prairie where the wind blew free, and there was nothing to break the light of the sun. I was born where there were no closures, and where everything drew a free breath . . . I know every stream and every wood between the Rio Grande and the Arkansas. I have hunted and lived over that country. I lived like my fathers before me, and like them I lived happily."
—Chief Ten Bears, Yamparethka Comanche

THE PRAIRIE

High, Wide, and Lonesome

On a day in early fall, a friend and I, hurrying under glooming clouds and fog in the foothills, headed our car southeast towards the prairie, to Picket Wire Canyon in the Comanche National Grassland. We were on our way to an enormous lake, just south of the town of La Junta, where Brontosaurus and Allosaurus dinosaurs roam, raising their young, preying upon each other, and scavenging for food among the lush, sub-tropical vegetation of tall palms, tree ferns, and cycads. We arrived about 150 million years too late, of course, but their enormous tracks remain, fossilized in limestone and shale outcroppings at the edge of this long-ago lake. More than 1,300 of these tracks have been documented here, making this site along the Purgatoire River the world's greatest known assemblage of dinosaur footprints.

We saw no other person on our trek that day, but what we did see exemplifies my fascination with Colorado's eastern prairie. The whole world seemed bathed in gold, the low light of fall accentuating the tawny colors in the tall grasses, the yellow of the rabbitbrush, and the sandstone bluffs. A brilliant blue sky arced overhead. Birds, pausing in mid-migration southward, were in abundance, a panoply of flash, wing, and song. Horned larks, headed for Mexico's warmer clime, swooped and dove. Western bluebirds perched on nearby cottonwood trees, while bushtits teased from the safe confines of greasewood thickets. Far overhead we heard the boisterous cacophony of dozens of sandhill cranes winging south before the onslaught of winter. In continuous motion they swirled against the cobalt sky, dark silhouettes changing abruptly to white as the sun caught and reflected the brightness of their feathers. In all we counted more than thirty species of birds along the way.

A tiny weathered chapel laboriously constructed by hand of stone gathered from the nearby canyon rested among weeds, its few parishioners long gone, and its sod roof a vague memory. Small gravestone markers incised in Spanish lent mute testimony to the struggles by long-forgotten Hispanic shepherds or cowboys in this inhospitable land.

Today, with the encroachment of civilization, little is left of the original prairie grasslands that once defined eastern Colorado. But here, at Picket Wire Canyon, we could imagine what explorers Zebulon Pike and Stephen F. Long must have seen in their early expeditions and what travelers on the nearby Santa Fe Trail witnessed as their covered wagons bumped across the prairie.

Major Long, dismissively termed the eastern prairie "The Great American Desert" and wrote that "it is almost wholly unfit . . . and

CLOUDS GLOW IN THE EVENING LIGHT ABOVE THE GRASSLANDS OF HUERFANO COUNTY.

uninhabitable for people depending upon agriculture for their subsistence. . . . The whole of the region seems peculiarly adapted as a range for buffalos, wild goats, and other wild game, incalculable multitudes of which find ample pasture. . . ."

Lieutenant Pike, however, viewed the prairie from a different perspective—both literally and figuratively. While unsuccessfully attempting to reach the summit of the mountain that now bears his name, he noted in his journal, "Arose hungry, dry, and extremely sore, from the inequality of the rocks on which we had lain all night, but were amply compensated for our toil by the sublimity of the prospect below. The unbounded prairie was overhung with clouds, which appeared like the ocean in a storm, wave piled on wave and foaming, while the sky was perfectly clear where we were."

Much of Colorado struts its famous scenery effortlessly. The Maroon Bells near Aspen hold their own with magnificent landscapes found elsewhere in the world as do the fiery display of aspen trees in the fall, the see-forever mountaintop vistas, the lush tapestry of wildflowers in Yankee Boy Basin, or the skyway drive over Independence Pass. There is an immediate response by one and all to such an extravagant display of natural beauty.

The eastern plains, however, too often get overlooked and shortchanged. These grasslands display a beauty that is far subtler, one that requires a slower pace and a keener eye. It's too easy to take a quick, impatient glance at the unbroken expanse of grass, sage, sand, and sky and decide there's nothing there in this land that ancient Native Americans referred to as the *wahoo*—the Great Circle of the Horizon.

A closer, more thoughtful, inspection, however, reveals a tantalizing abundance of bird life, brilliantly colored tiger beetles and burrowing owls, sand sage and juniper, fleet-footed pronghorn, and the mournful yelp of the coyote. It's lonesome country, its spaces defined by strips of barbed wire, its silence broken only by the wind and a raptor's cry.

Upon looking further, one discovers that the land is not so barren or flat after all, but has buckled, folded, upturned, and continuously rearranged itself through the ages. The resulting canyons, buttes, and volcanic remnants present myriad shapes and sizes in varying hues, beckoning for further exploration.

The prairie fans out in accordion-like pleats as it steadily gains altitude from its lowest point in Colorado at just 3,300 feet on the Kansas border until it meets the foothills along the Front Range of the eastern Rocky Mountains. Two major rivers, the Arkansas and the South Platte, bisect the area, watery webs of life in a region that averages only sixteen to twenty inches of rain a year.

To walk across the prairie is to tread upon layer after layer of geologic time. Its underlying foundation consists of the remains of the Sundance Sea, an enormous inland sea originating almost 100 million years ago that ran from the Arctic Circle to the Gulf of Mexico. Then, slowly, a major uplift of the land caused the waters to recede and the sea to empty. Over time, rock and soil washed down

from the emerging mountains to the west, filling the basin of the vanquished sea. This wall of mountains created a rain shadow, blocking the moist flow of air from the Pacific and causing the region gradually to dry out.

On the now-arid plains a variety of grasses took hold, spreading ubiquitously to form a vast area named the Sea of Grass by Native Americans. Scientists theorize that the grasslands evolved concurrently with early herbivorous animals of the plains—camel, pronghorn, elk, deer, and buffalo—each adapting to the requirements and physiology of the other. Animals depended upon grass for sustenance, while grass, in turn, needed the stimulation of grazing for optimum viability and health.

Grazing animals have evolved to eat and digest a steady diet of grass through adaptations to their teeth and stomachs. Since many grazers eat on the run, keeping in motion to avoid predators, their bodies have the capacity to delay digestion of the grass—a complicated process in itself—to a later, more convenient, time.

Unlike most plants, grass grows from the base and not the tips and actually needs grazing to stimulate new growth. Historically, bison performed this role, one that was mutually advantageous to the bison and to the grass. Today, cattle can play a similar, vital part in keeping grasslands healthy.

Survival on the prairie is not for the meek. Both animal and plant adaptations are designed to withstand the paucity of trees, moisture, and soil as well as searing winds, violent storms, and gyrating temperature extremes.

Extraordinary speed coupled with acute vision and hearing are the common denominators for wildlife. With no trees to climb, few shrubs to hide under, and no protecting boulders to scurry beneath, keen senses and the ability to outrun an adversary are often lifesaving attributes.

The graceful pronghorn, the most prominent animal of the plains, is capable not only of running at great speeds but is also able to reach these speeds almost instantaneously. Commonly but mistakenly referred to as antelope, pronghorn are built for action. Their disproportionately long, slender legs skim the ground horizontally while running, avoiding the up-and-down motion most other animals employ. Clocked at speeds of up to sixty miles an hour, they can easily outrun their perennial enemy, the coyote. Pronghorn fossils dating back 25 million years are almost identical to the pronghorn of today, indicating little evolutionary change from their long-ago ancestors.

Smaller animals are equally swift. Jackrabbits bound effortlessly, propelled by powerful hind legs; prairie dogs and mice dive into nearby burrows at the first hint of trouble, while the irrepressible roadrunner *beep-beeps* off to safety on long, skinny legs dedicated to speed.

Velocity is the watchword on the prairie, not only for animals but also for wind. Wind is a constant, searing companion, sending tumbleweeds scurrying across the unbroken landscape and forcing cattle to huddle together, shoulder to shoulder, braced against the

onslaught. Dust storms appear out of nowhere, muddying the sky, and blizzards tear through the land, leaving an eerie, frozen moonscape in their wake. Just as suddenly, a warm Chinook wind replaces the cold one, melting the snow and drying out the landscape once again.

Plants that inhabit the prairie have a number of strategies for survival. Most are small in stature, nestling close to the ground where the wind cannot rip through them. Often, a plant's root system consists of two different types: shallow ones, close to the surface, to take advantage of scant rainfall, as well as long taproots that bore into the ground as much as ten feet in search of moisture.

The shortgrass prairie is like a rainforest in reverse: In a rainforest, plants in the aboveground canopy compete for space, light, and nutrients; but on the prairie, the fight is underground among the roots as they search for water and sustenance, duking it out for survival. Rainforest plants grow in dense proximity to each other, while those on the prairie are sprinkled widely apart in polka-dot fashion across the landscape, allowing each plant sufficient room to find water and nourishment.

As a defensive mechanism against evaporation, the leaves of many prairie plants have diminished surfaces. Spines have evolved in the cactus family, with similar, needle-like foliage on evergreen pines and junipers. Broad-leaf varieties may have protective waxy coatings or be covered with fine, soft hairs.

Nearly all plants of the prairie grow upright, providing less horizontal surface for the overhead sun to dry out, but allowing vertical exposure to early and late sunlight for necessary photosynthesis.

Dormancy is the ultimate fallback for water-stressed plants. They simply "nod off"—to put it in human terms—until the heat or drought subsides, and then are able to bounce back quickly once conditions improve.

Not far from Picket Wire Canyon, but representing a totally different environment, are the Spanish Peaks, dual watchtowers over Colorado's southern country. Soaring above the rocky mesas below, they are volcanic, having thrust up through the inland sea, and were originally much higher than their current altitudes of 12,683 and 13,626 feet. A number of dikes—thin walls of hardened lava—radiate out from the base of the peaks, nature's mimicking of the Great Wall of China. These dikes were originally fissures in the ground below the volcanoes that filled with igneous material when they erupted. Today, the landscape is reversed: The original soil that surrounded the dikes has now eroded away, leaving these fascinating formations above ground rather than below.

Early Indians thought the site was haunted and avoided it, but Spanish explorers, hearing rumors of gold, had no such qualms. In the museum in nearby La Veta, the elaborately decorated seventeenth-century sword of a Spanish adventurer is on exhibit, a lone, symbolic relic of the dreams of empires and wealth that fueled the quest of these New World Don Quixotes.

In the northeast part of the state, the Pawnee Buttes, two other guardians of the plains, stand guard. Located in the Pawnee National Grassland amidst some of the most dramatic scenery on the plains, they reign over a prairie kingdom of waving grasses—for here the wind *really* blows—countless birds, and a treasure trove of fossils. The night sky is strewn with stars, their brilliance undiminished by any lights from civilization.

Pawnee Buttes are located in one of the last vestiges of untouched shortgrass prairie, resting atop remnants of the same tropical inland sea that once covered Picket Wire Canyon. They are regarded as world-class paleontology digs. More than a hundred species of vertebrate fossils have been unearthed here, including rhinoceros, ancient pigs and camels, a hippopotamus relative, and several types of horses along with a number of extinct bird species.

In the pervasive silence one can look up at the raptors nesting in the chalk bluffs, down at the abundant wildflowers that appear in early June, or out, at the unbroken expanse of grass that seems to extend forever.

Along the Front Range, 14,000-foot peaks and the low-lying prairie are situated in close proximity—sometimes separated by a distance of only twenty miles. Insinuating itself between these two extremes, is a long, broad valley, the Colorado Piedmont, extending on a north-south axis that parallels the mountain ranges. Hogbacks—spiky, vertical rock slabs—rise like random exclamation points at intervals along the way.

Uplift of the westerly mountains and subsequent erosion along their eastern flank sculpted this valley and, in the process, caused small stream and rivers cascading down from higher elevations to change directions. The two great rivers of the plains, the South Platte and the Arkansas, run generally west to east, but nearly all of their tributaries, such as Cherry Creek and the Purgatoire and Huerfano Rivers, flow north to feed into them.

The geologic confluence of mountain and prairie has spawned some magnificent, rugged scenery, and one could do worse than spend some time in the foothills here, exploring the natural wonders at Castlewood Canyon State Park, Garden of the Gods and North Cheyenne Cañon in Colorado Springs, Denver's Red Rocks Park, and the Cache la Poudre River Canyon west of Fort Collins.

In this transition zone between the earth and the sky is gathered the greatest variety of plant and animal life found in the state. High- and low-altitude life forms meet here, presenting spectacular viewing opportunities for birders, plant hunters, and leaf lookers.

For more than twenty-five years, I have lived in this transition zone, in the foothills high above Colorado Springs, and have long reveled in this altitudinal, species-abundant meeting ground. Bluestem grasses from the prairie, scrub oak—the predominant tree of the foothills—and Douglas fir from the high country all grow quite equitably together in my yard. I see coyotes, great horned owls, and flocks of cedar waxwings, denizens of the plains. I spot turkey on the ridge above me, but am also visited by black bear and Steller's jays, typical residents of the high country.

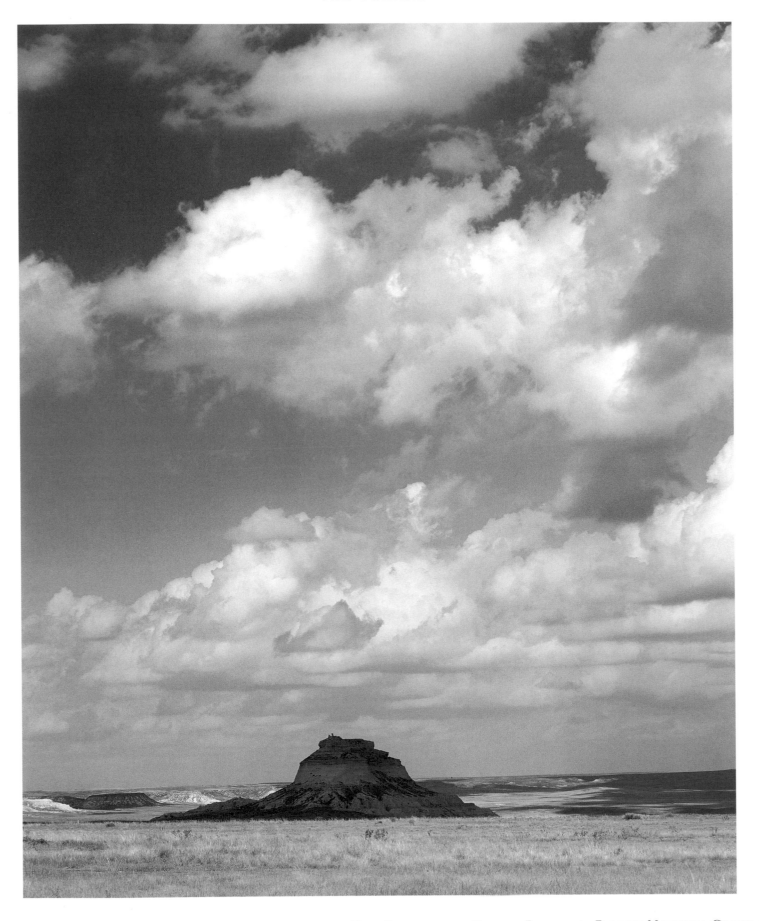

SUNLIGHT AND CLOUDS ALTERNATELY HIGHLIGHT AND SHADOW EAST BUTTE IN THE PAWNEE BUTTES OF PAWNEE NATIONAL GRASSLAND.

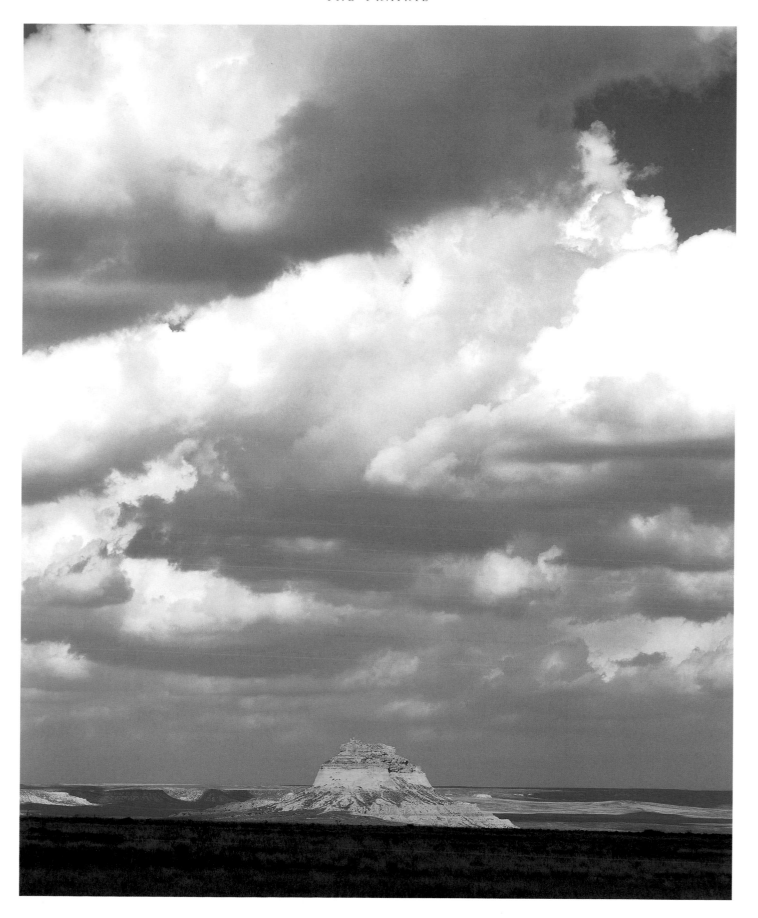

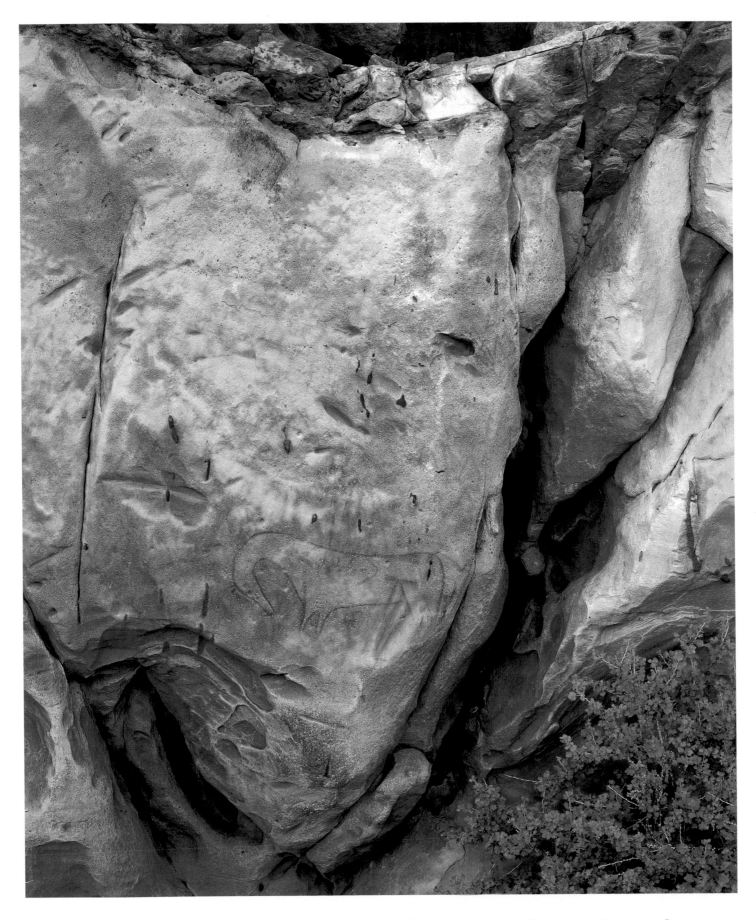

A PETROGLYPH OF A HORSE SHIMMERS ON A SANDSTONE CLIFF IN PICTURE CANYON, COMANCHE NATIONAL GRASSLAND.

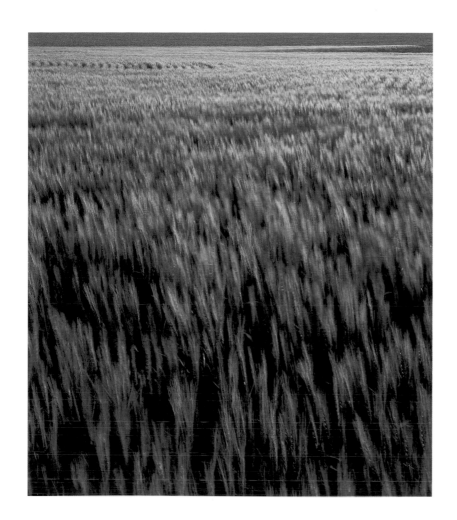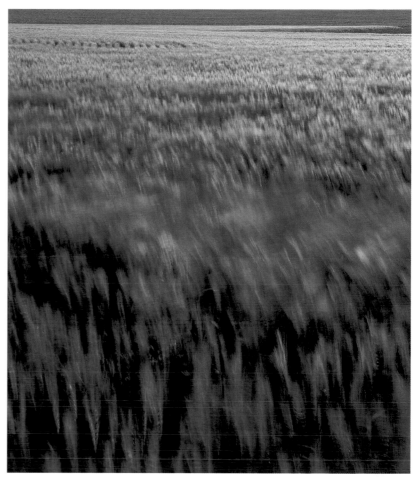

THE WIND BLOWS THROUGH A FIELD OF BARLEY IN KIT CARSON COUNTY.

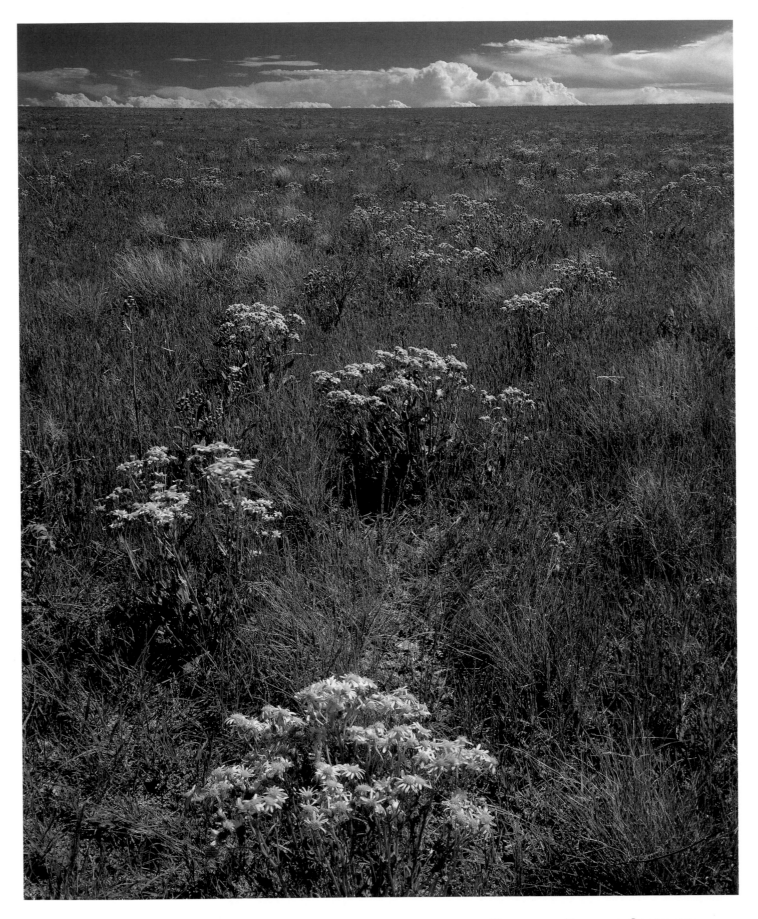

THE YELLOW FLOWERS OF SENECIO STAND OUT AMONG THE GRASSES OF COMANCHE NATIONAL GRASSLAND.

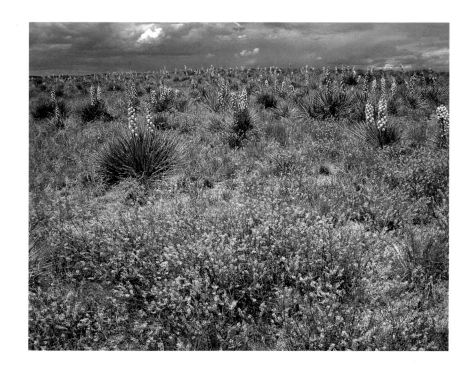

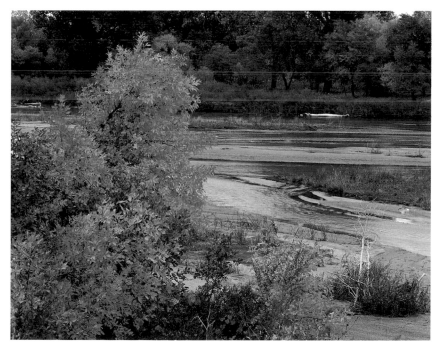

ABOVE LEFT: YUCCA BLOSSOM IN THE PAWNEE
NATIONAL GRASSLAND.

ABOVE: OAK TREES SHOW THEIR AUTUMN COLORS ON THE
GREENLAND RANCH IN DOUGLAS COUNTY.

LEFT: THE FIRST FALL COLORS ERUPT ALONG THE SOUTH PLATTE
RIVER NEAR ATWOOD IN LOGAN COUNTY.

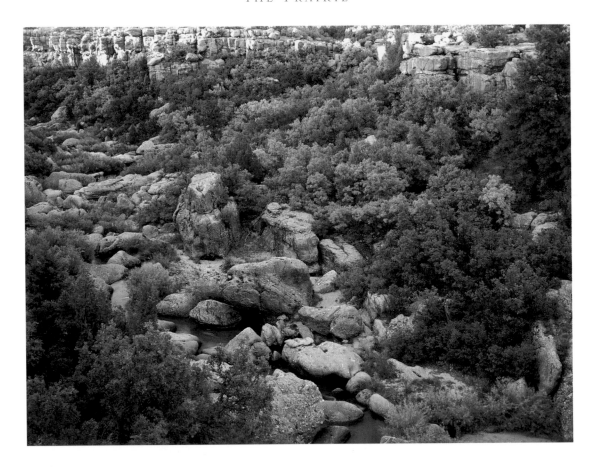

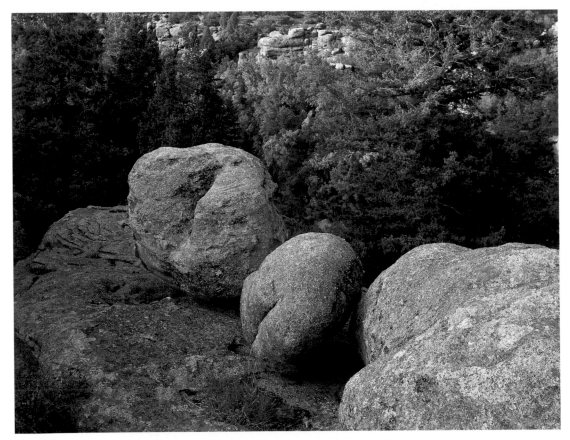

FALL COLORS GLOW AMID THE ROCKS OF EAST CANYON IN CASTLEWOOD CANYON STATE PARK.

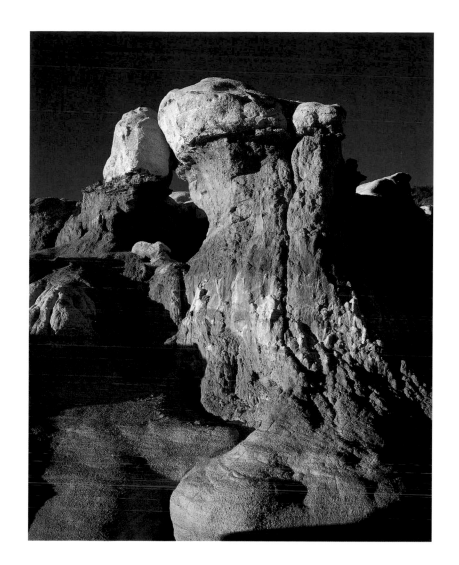
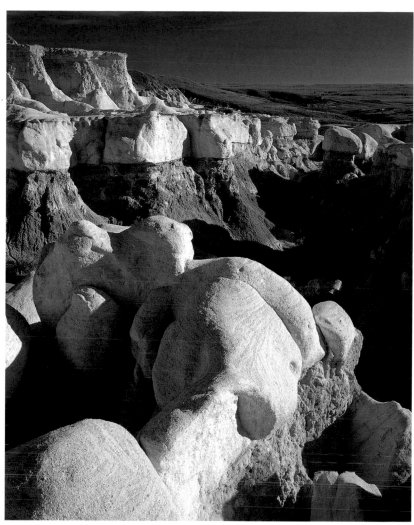

THE STRANGE HOODOO ROCK FORMATIONS AT THE PAINT MINES IN EL PASO COUNTY.

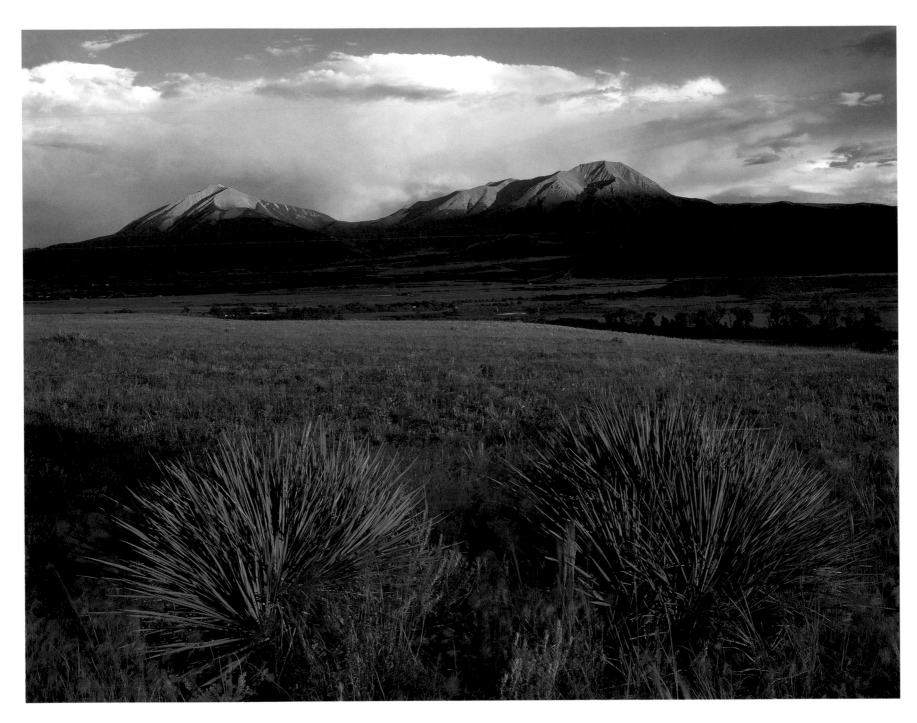

THE COMING OF EVENING LIGHTS THE SPANISH PEAKS ABOVE LA VETA IN HUERFANO COUNTY.

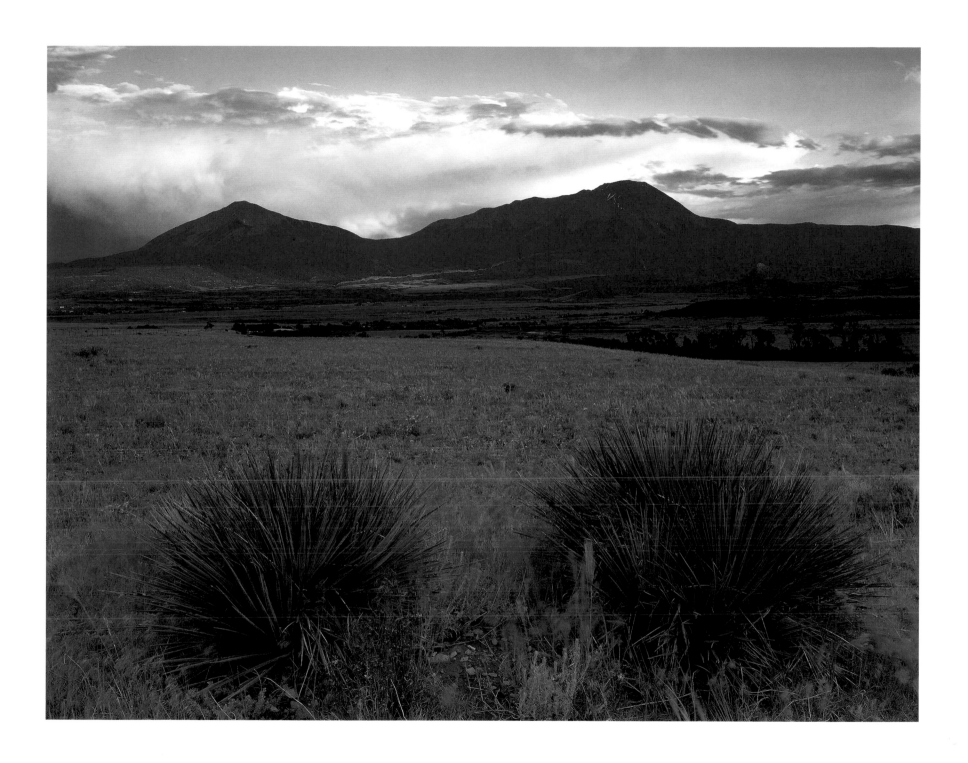

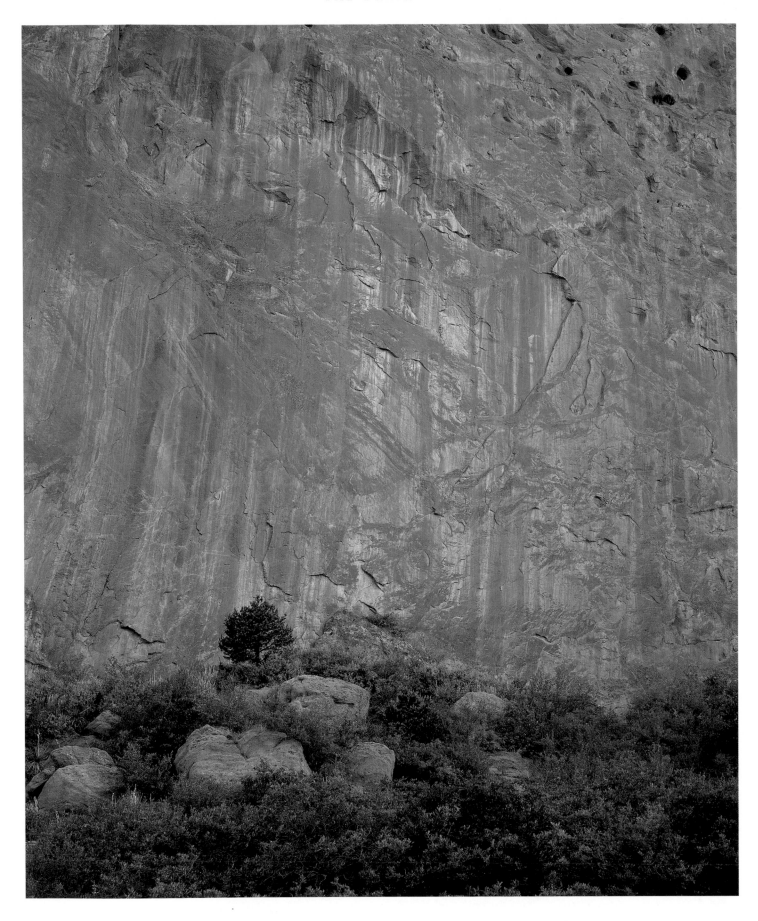

A rich, red cliff presents an imposing face at the Garden of the Gods in Colorado Springs.

LICHEN-COVERED BOULDERS IN THE NATURE CONSERVANCY'S
AIKEN CANYON PRESERVE IN EL PASO COUNTY.

BOULDER FORMATIONS IN NORTH CHEYENNE CAÑON PARK IN
COLORADO SPRINGS.

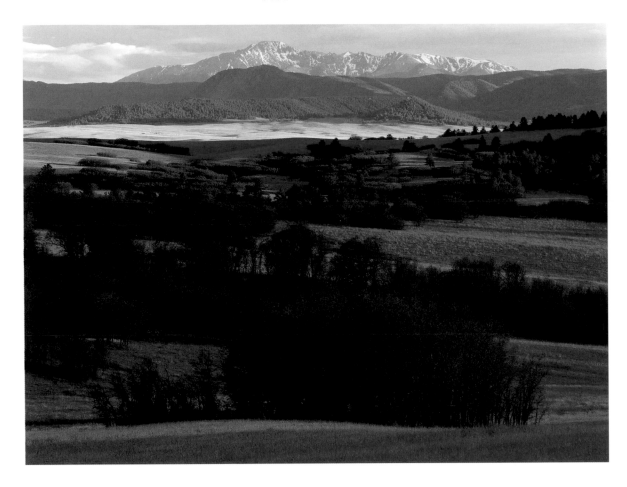

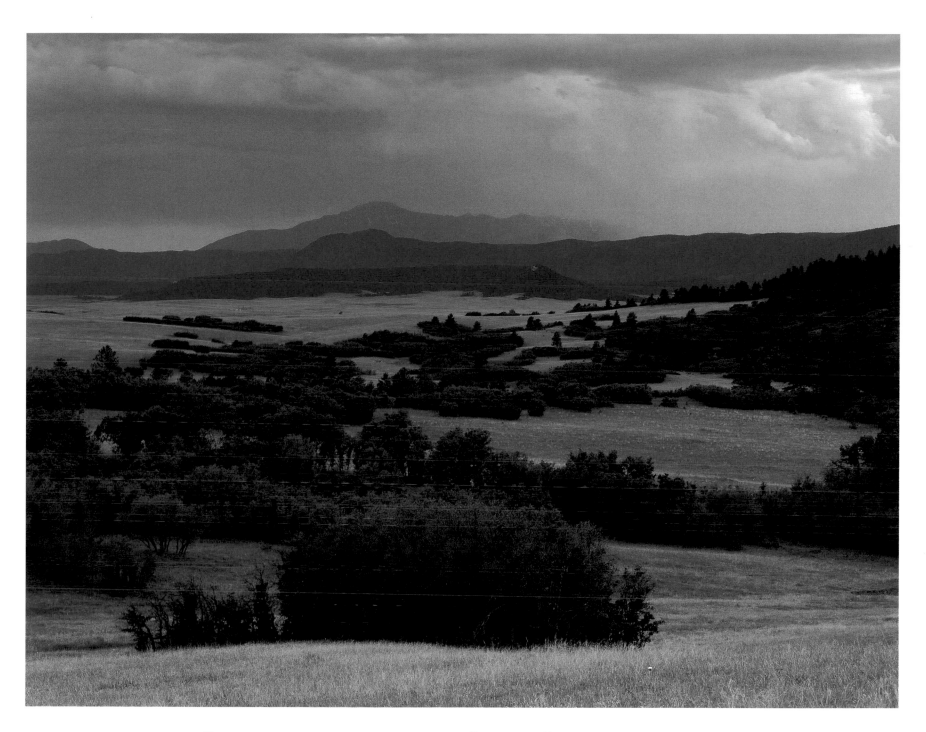

THE SETTING SUN LIGHTS THE HILLS OF THE GREENLAND RANCH IN DOUGLAS COUNTY.

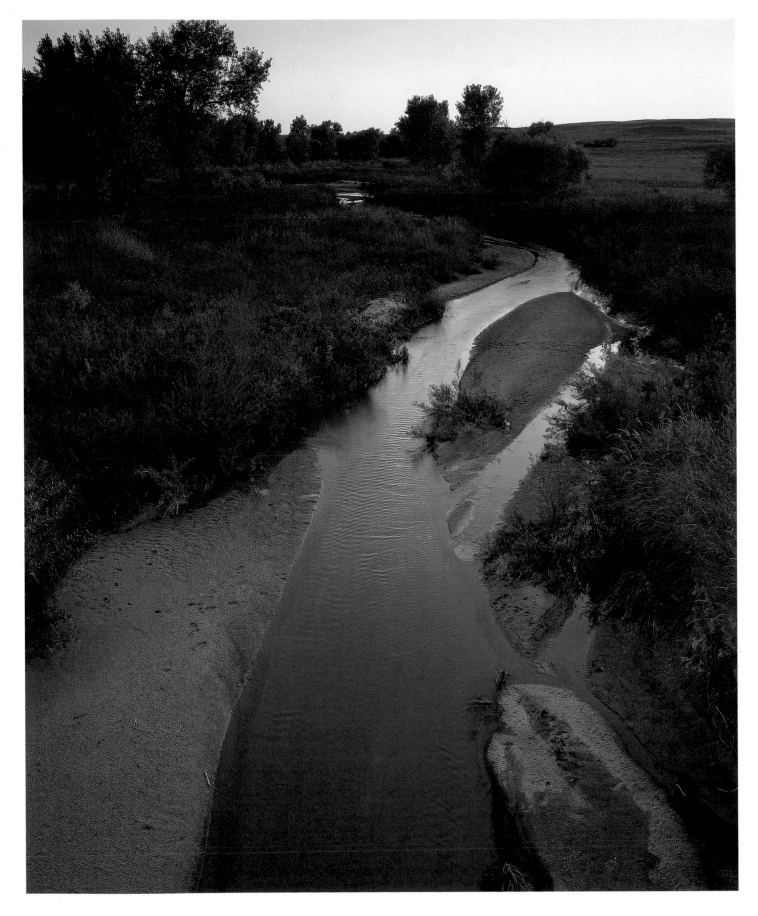

THE LAST LIGHT OF DAY SHINES OVER THE ARICKAREE RIVER IN THE SANDY BLUFFS WILDLIFE MANAGEMENT AREA, YUMA COUNTY.

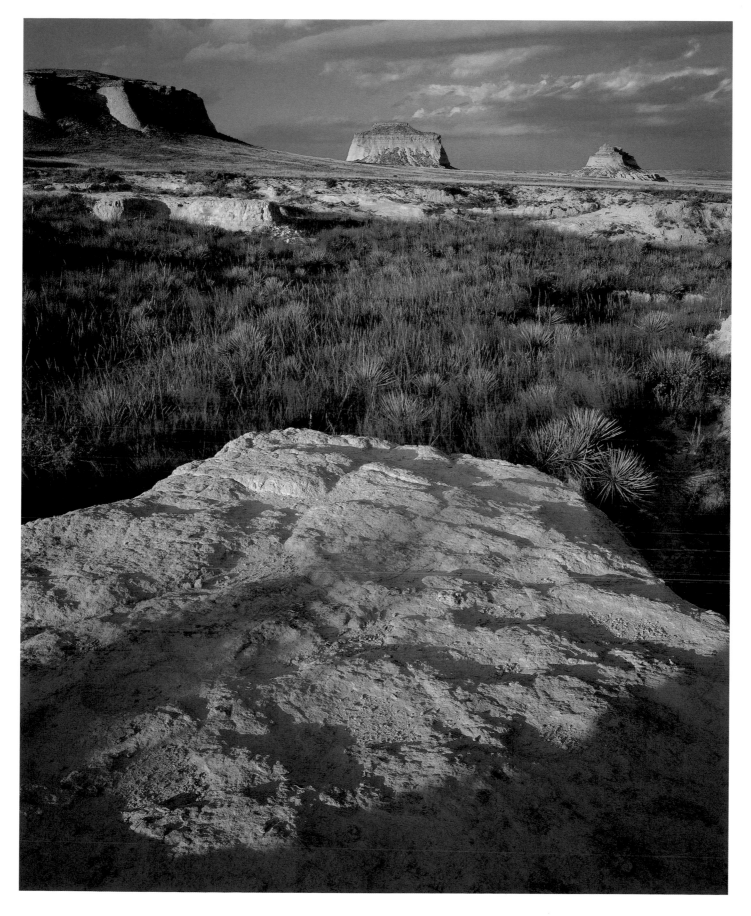

THE PAWNEE BUTTES SHINE AT SUNSET IN THE PAWNEE NATIONAL GRASSLAND.

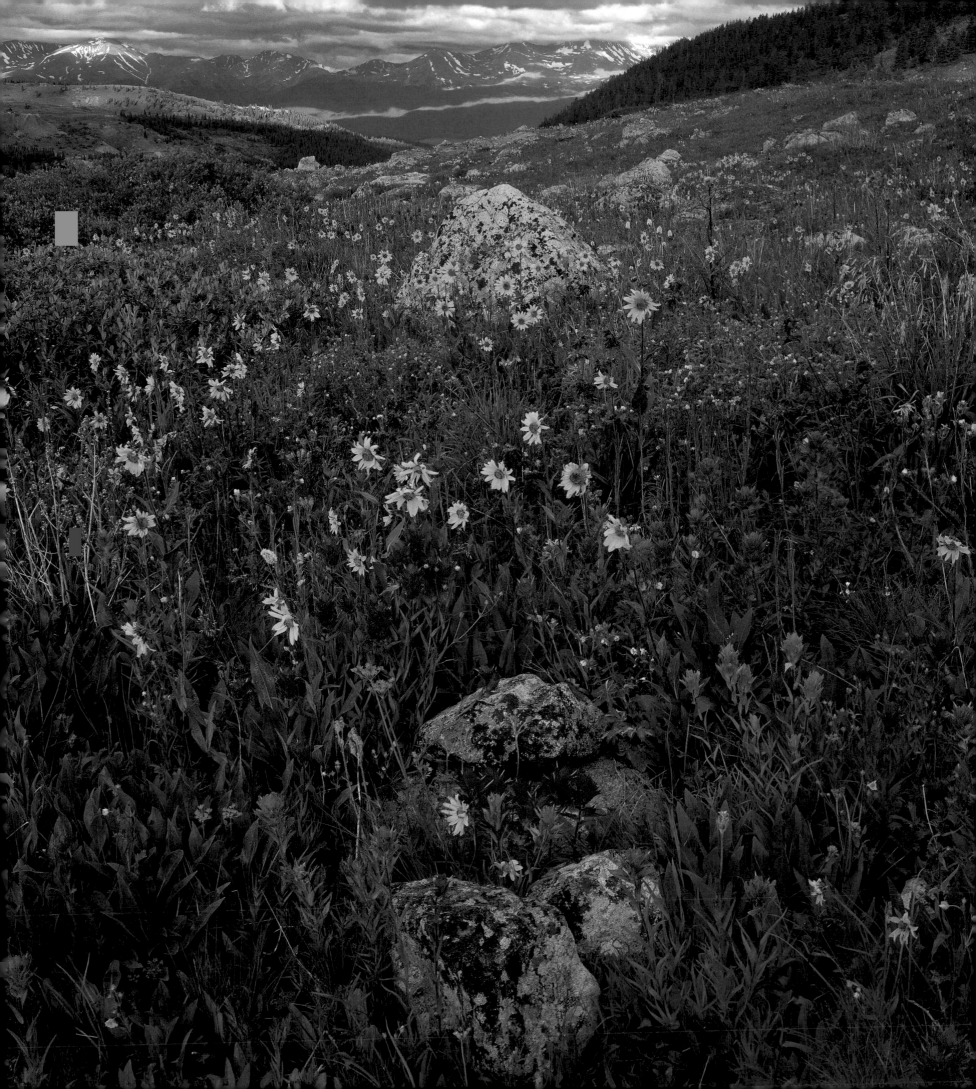

"What I love is near at hand. Always in earth and air."
—Theodore Roethke

ALONG THE FRONT RANGE

Gateway to the High Country

The first explorers must have reacted with dismay at the seemingly endless, impenetrable wall of mountains that greeted them as they headed west. Even today, these rocky sentinels appear on guard, standing shoulder to shoulder against all who seek to penetrate into their midst. Only in a few places, along fault lines where wind and water have carved narrow passageways, have the mountains relented, allowing access into their inner domain.

The topography along these passageways changes swiftly and dramatically, revealing tantalizing clues about the high country that lies ahead. One such corridor, Ute Pass, rises steadily from the western boundary of Colorado Springs, opens up for a glimpse of Pikes Peak, and then winds sinuously through the Tarryall Mountains, higher and higher on a straight shot to the top of Wilkerson Pass.

There, at 9,500 feet, a dramatic and diverse world awaits, spreading out as far as the eye can see. Far off, ranged against the western sky, are the high peaks of the Sawatch Range, containing fifteen peaks over 14,000 feet. To the north, the Tarryalls blend into the Rampart Range, while to the east is an unencumbered panorama of Pikes Peak's massive, imposing presence. Off to the south, past ancient volcano fields, the high peaks of the Sangre de Cristos are faintly drawn against a hazy horizon.

Lying far below is the vast expanse of South Park, one of four great natural parks that are scattered like loose pearls through the center of the state, verdant, grassy pauses between mountain ranges. Not parks in the usual urban sense, these are naturally occurring, wide-open spaces. Trees do not grow here—it's too high, dry, and cold—so these parks contain only sweeping grassy shrublands, framed by jagged, rocky peaks.

South Park is the most central of these mountain parks. Bison by the thousands once grazed here, hunted by nearby Ute, Arapaho, and Cheyenne Indians, trappers, and mountain men. Arrowheads and spear points can still be found, brought to the surface by repeated frost action and further exposed by spring rains.

Gold was discovered in nearby Fairplay in the late nineteenth century, igniting a rush of prospectors that faded away as quickly as it began, leaving behind piles of mine tailings that can still be seen, mute evidence of man's optimism checkmated by grim reality.

The most notorious resident of South Park was probably Old

A HIGH MEADOW OF WILDFLOWERS BLOSSOMS IN MOSQUITO PASS IN THE MOSQUITO MOUNTAIN RANGE
OF THE SAN ISABEL NATIONAL FOREST.

Mose, a giant of a grizzly bear, 1,200 pounds of malevolence and cunning, that roamed through the valley for a quarter of a century. His hunting skills were legendary: The demise of 800 head of cattle was attributed to him. He mauled three men to death before his own end came, in 1912, when a party of trappers, assembled with the explicit mission of eliminating Old Mose, finally brought him down. Not only was Old Mose one of the largest grizzlies on record, he was also one of the last, as the extinction of the few remaining grizzlies in Colorado occurred about the time of his death.

The fens of South Park are an exception to the region's generalized arid landscape. Fens are unusual phenomena in nature occurring where wet, peaty areas are fed primarily by underground springs. High Creek Fen, a Nature Conservancy Preserve on the west side of South Park, is one such gem—a unique combination of rare plants and ecologic diversity that also serves as a great attraction for birds.

The immense San Luis Valley, southernmost of the parks and containing the only true desert region in the state, is an ecological anomaly, like nowhere else in Colorado. Bigger than all of Connecticut, it is a place of water, wind, and sand, its natural history not easily aligning with either Colorado or neighboring New Mexico.

The San Luis Valley was created when it was left behind as the surrounding mountains uplifted, the result of interconnected shifting that began some 25 million years ago and extended all the way south into Mexico along the Rio Grande River drainage. The foundation of the valley floor actually rests below sea level. A complicated sequential layering of sediment created an enormous amount of sub-surface water that today is the lifeblood for the ecology and the people of the valley.

The sandwiching effect of the San Juan Mountains to the west and the Sangre de Cristos to the east created some of the largest and highest inland sand dunes in the world. They are the product of millions of tons of sand particles blown by prevailing winds in a constant, northeasterly direction. Slamming into the mountain massif to the east, they fall to the ground, forming ever-shifting, ephemeral dunes.

Our day at Great Sand Dunes National Park and Preserve was spent being a kid again in a giant sand pile just waiting to be romped through. First, we waded across Medano Creek, a challenge because of its unique pulsing flow. This flow is the result of water-crafted, mini-dams of sand that are continually building to block the water's course and then break down, sending the water surging downstream. Timing was everything here in trying to avoid wet jeans and t-shirts.

Once across the creek, the fun began. We tumbled and slid down the slopes, made sand angel imprints, watched a dung beetle struggle to roll its ball of dung—what else?—uphill, a metaphor, we mused, of some of the unnecessary baggage we take on in our own lives. Our friend and guide pounced suddenly, frantically digging into the wet sand and coming up with a fistful that she carefully brushed away, revealing a tiny, exquisite creature, the endangered tiger beetle.

Under a high-powered hand lens, its intricate beauty was revealed, beautiful markings on a shimmering bronze body.

We clamored to the top of the highest dune, some 700 feet above the valley floor. Below us, as the valley fanned out, we traced the course of the Rio Grande River. Snow-smothered peaks rose high before us, silent witnesses to the life spread out below them.

The road winding up Ute Pass skirts the edge of Florissant Fossil Beds National Monument where the fortuitous sequencing of several cataclysmic geologic events provides a window for a wondrous look into the past. Some 35 million years ago a volcanic mudflow created an instant lake here and, at the same time, buried sequoia trees that were growing there, as grand in scale as those seen in California today.

Lush understory vegetation grew up along the shores of this lake, a welcoming environment for birds and animals as well. The ash from subsequent volcanic eruptions gradually filled the lake, gently burying and preserving insects, birds, butterflies, fish, plant life, and small mammals in layers of ash and silt. Then a final eruption capped the lakebed with a hard layer of tuff, thereby protecting it from future environmental damage.

The lakebed remained undisturbed for millions of years, as its earlier inhabitants slowly fossilized. Then, when widespread uplift occurred all over the state, the sediment containing the fossil came to the surface, yielding thousands of beautifully preserved specimens from a long-ago past—the most extensive collection of its kind in the world.

None of the fossils are big-bruiser, dinosaur types. Instead, exquisite plants and insects are presented in delicate detail, finely drawn etchings in the shale, the "life" in them amazingly intact. A wolf spider appears ready to spring into motion, the fronds of a fern display stunning grace and movement, while a dragonfly seems poised to zoom off in flight.

The delicacy of the fossils and the violent physical forces that created them are polar opposites, intriguing reminders of the contrasting intricacies of the natural world. As Arthur Peale, a geologist with the 1873 Hayden Expedition who is credited with the discovery of this treasure, wrote, "When the mountains are overthrown and the seas uplifted, the universe at Florissant flings itself against a gnat and preserves it."

The mountains of the eastern slope are the ones I know best and love the most. I am strongly drawn to mountains, a connection that I cannot fathom or explain but is an intrinsic part of my life, a lodestone for my whole being. Perhaps it's a reaction to my childhood, growing up in a flat, uninspiring Texas urban environment, or perhaps it was summers spent in the high country of New Mexico that made such a lasting, indelible impression on me.

Mountains are the landscape and the refuge of my spirit. Hiking and climbing among them enable me to explore with all my senses the peaks and valleys that I so love. My family says that hiking with

me is like strolling along with Ferdinand the Bull—that I stop to poke my nose in every wildflower along the way. And I can't deny it, because I do indeed pause—to look, to inhale, to inspect, to exult, to exclaim, and then to arrive, finally, breathless, at the top, exhilarated by the climb, humbled by the view. I climb not necessarily to get to the top but for the experience along the way. It *is* the journey that matters and not the destination.

No two mountains are ever the same, and each that I have climbed has remained with me in amazing clarity. Always, there are surprises along the way, small moments that stand out in memory: feeding a friendly marmot that ate the lettuce from my sandwich but spurned the proffered grapes; stuffing my pack with a harvest of edible King Bolete mushrooms happened upon at the end of a rainy summer (for mushrooms, they were amazingly heavy); quietly backing away after an unexpected encounter with a mother sage grouse clucking anxiously, instinctively protecting her chicks from the perceived danger that I posed.

But it is the dazzling wildflower display that calls most strongly to me, drawing me, weary and breathless in the high altitude, ever upward. I play a game with myself, mentally calculating the altitude by identifying the flowers at my feet, most of which, I know, are quite altitude-specific in where they choose to grow. Crossing a stream, a bright, raspberry-colored Parry primrose confirms what my eyes and lungs have been telling me—that I am in a wet, subalpine meadow.

Named after C. C. Parry, an early-day scientist who studied the botany of the West, this primrose is often found along fast-moving streams, tucked close to a rock, its roots seeking purchase underneath. I, being Ferdinand the Bull, bend down to look more closely, and immediately pick up a strong, unpleasant aroma—a protective mechanism produced by the flower to keep herbivorous insects and mammals at bay. As I continue my climb, I muse over the quirkiness of this lovely flower that manages to be both compelling and repelling at the same time.

Subalpine mountain meadows from 9,000 to 11,000 feet often provide the most spectacular displays of wildflowers found anywhere

in the state. Several factors combine to create this lush environment: Glacial action scooped out low-lying areas between and below the mountain tops; and the soil that was subsequently deposited there by wind and erosion is fine-grained, wet and deep—precluding encroachment in the meadows by trees whose roots dislike such moisture. Additionally, rich nutrients in the soil allow the flowers to grow in closely packed, dense proximity to each other, creating a carpet of dazzling variety and color.

These meadows are characterized by a great abundance and diversity of plants. Paintbrush, gentians, iris, asters, forget-me-nots, primroses, lupine, fireweed, and chiming bells meld together in a stunning palette of color, shape, and variety. The resulting show of midsummer bloom provides, in the words of Theodore Roosevelt, "scenery to bankrupt the English language." Roosevelt was actually referring to the grandeur of Colorado when he spoke these words, but I insert them here since they so aptly describe one's struggle to put such extravagant beauty into words.

Wind is an inevitable companion in the high country, whistling through canyons and scouring peaks and valleys. Its velocity increases at higher elevation, and storms of hurricane-force approaching 100 miles an hour are not uncommon above tree line.

Ironically, the world's oldest trees bristlecone pines—are found in the windiest, most-exposed rocky ridges and ledges. Unable to compete against the more-aggressive fir and spruce, they thrive in areas unsuitable for other trees. Extremely slow growing—in order to preserve energy in these desolate sites—the bristlecone pine's resulting wood is incredibly dense, creating an impenetrable barrier for the destructive forces of fire and insects.

As they cling, gnarled and determined against the elements, fantastical shapes emerge as continual winds twist and abrade the trunks, and treetops are flattened by gales. Long-dead trees stand among the living, their limbs buffed silver by exposure. Lonely sentinels, high above the valley floor, these Colorado Methuselahs live for more than a thousand years, while their counterparts in California's Sierra Nevadas date back almost 5,000 years.

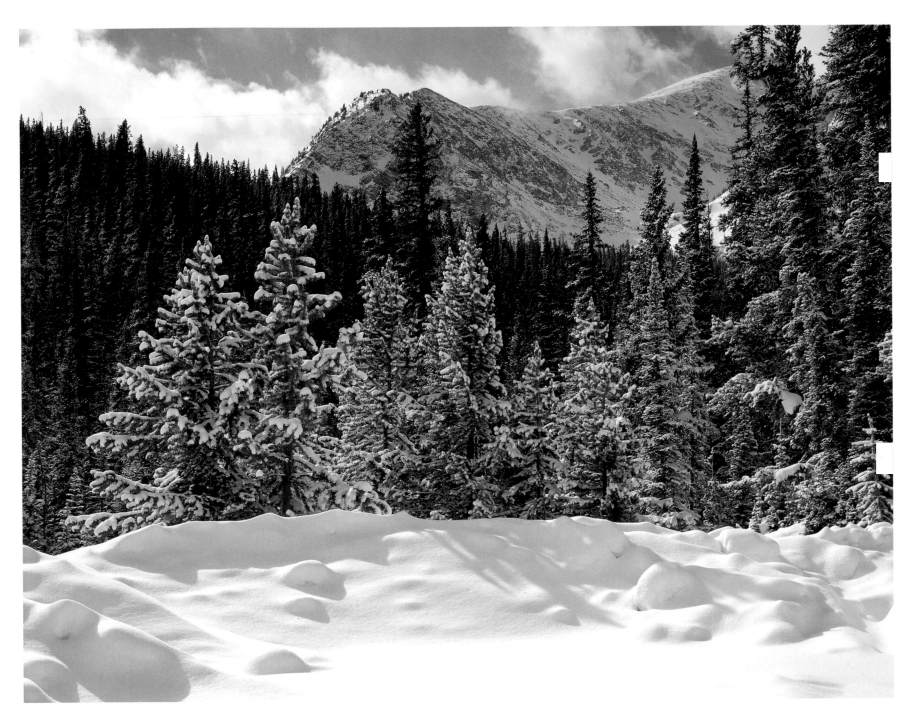

SNOW COVERS ALL AT COTTONWOOD PASS IN THE SAN ISABEL NATIONAL FOREST.

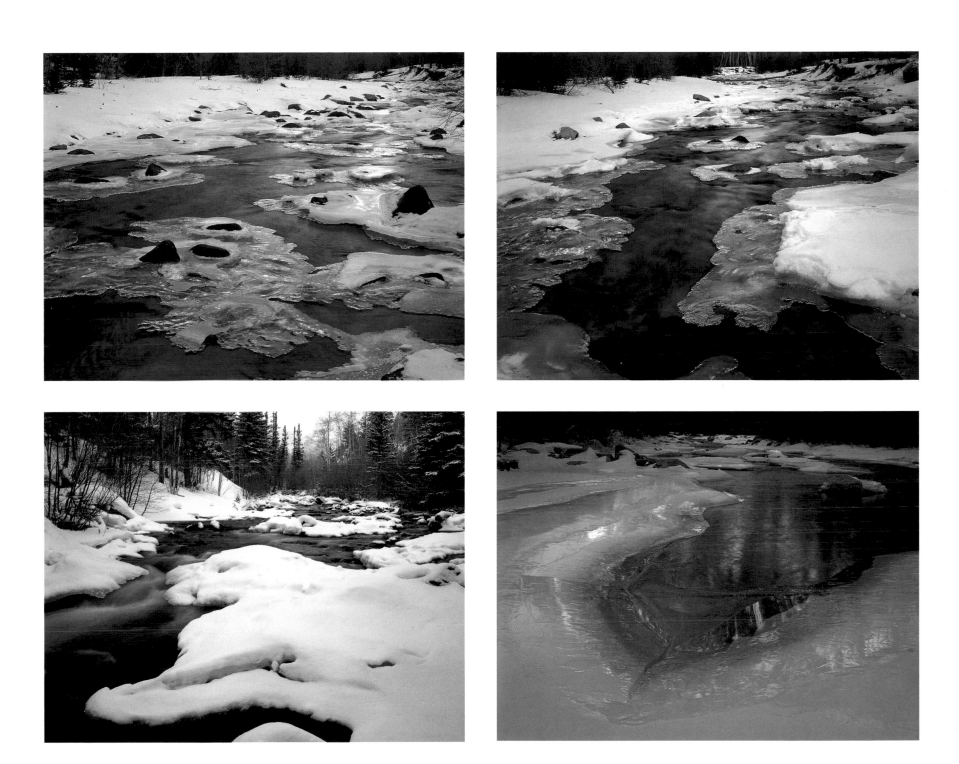

ICE, ROCKS, AND WATER CREATE IMPRESSIONISTIC PATTERNS IN ROCKY MOUNTAIN STREAMS.

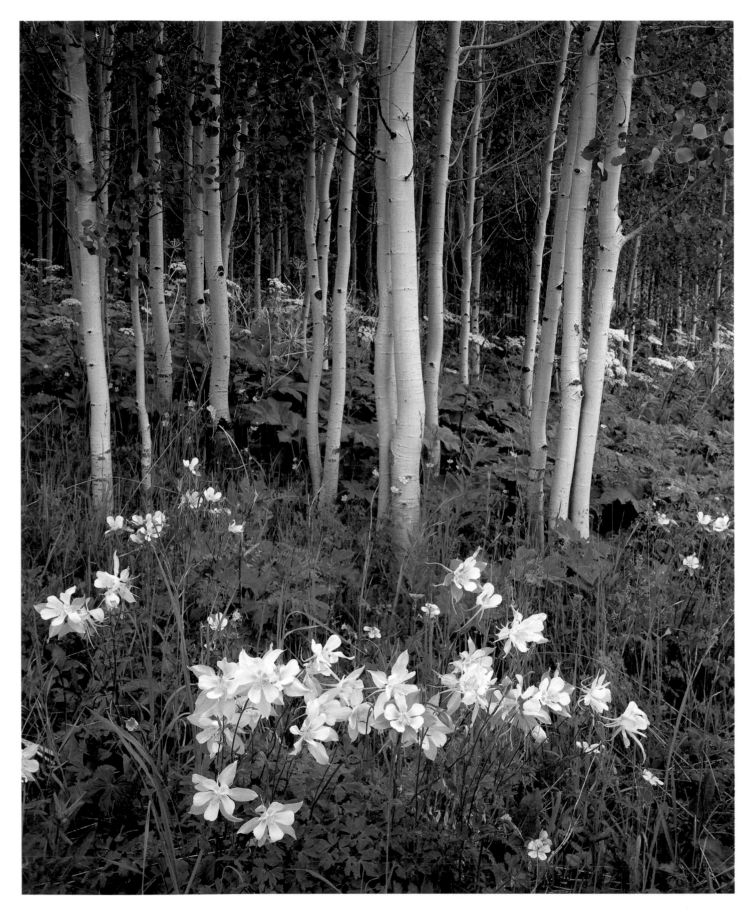

Columbines bloom at the foot of an aspen grove.

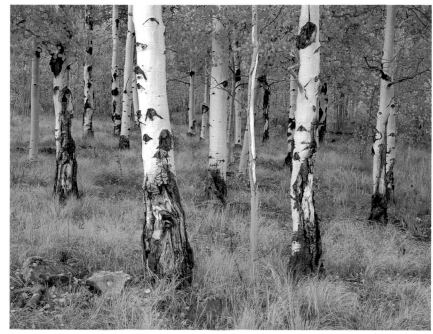

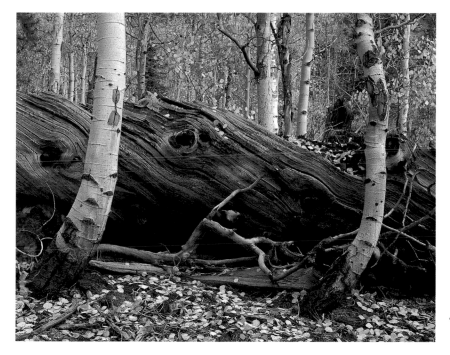

GROVES OF ASPENS GROW IN THE SAN ISABEL NATIONAL FOREST.

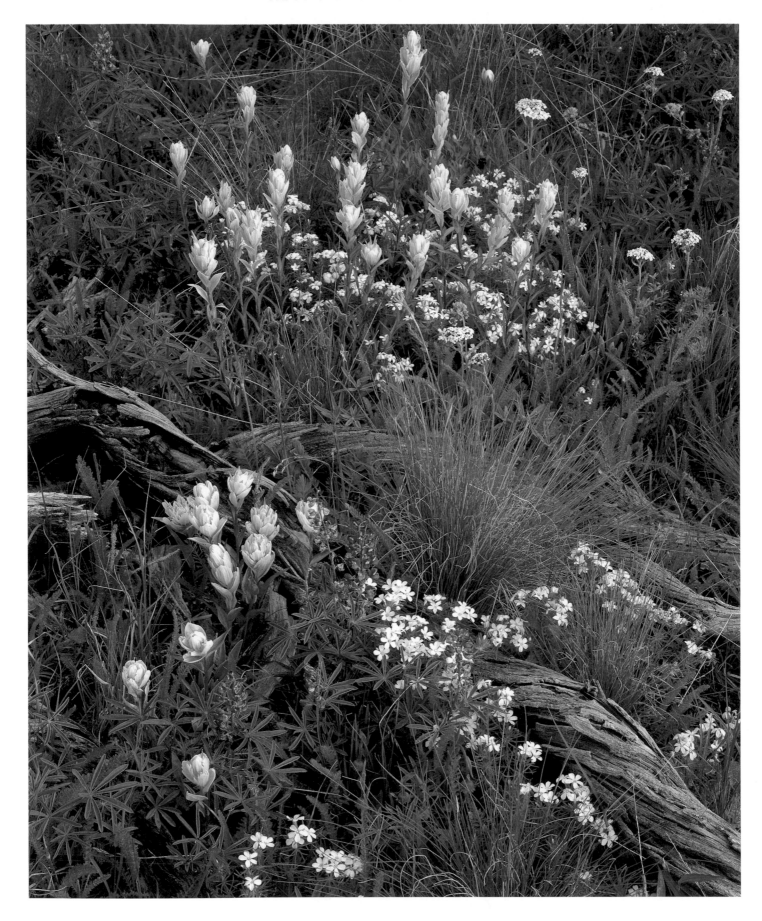

WILDFLOWERS BLOSSOM IN THE MOSQUITO RANGE OF THE SAN ISABEL NATIONAL FOREST.

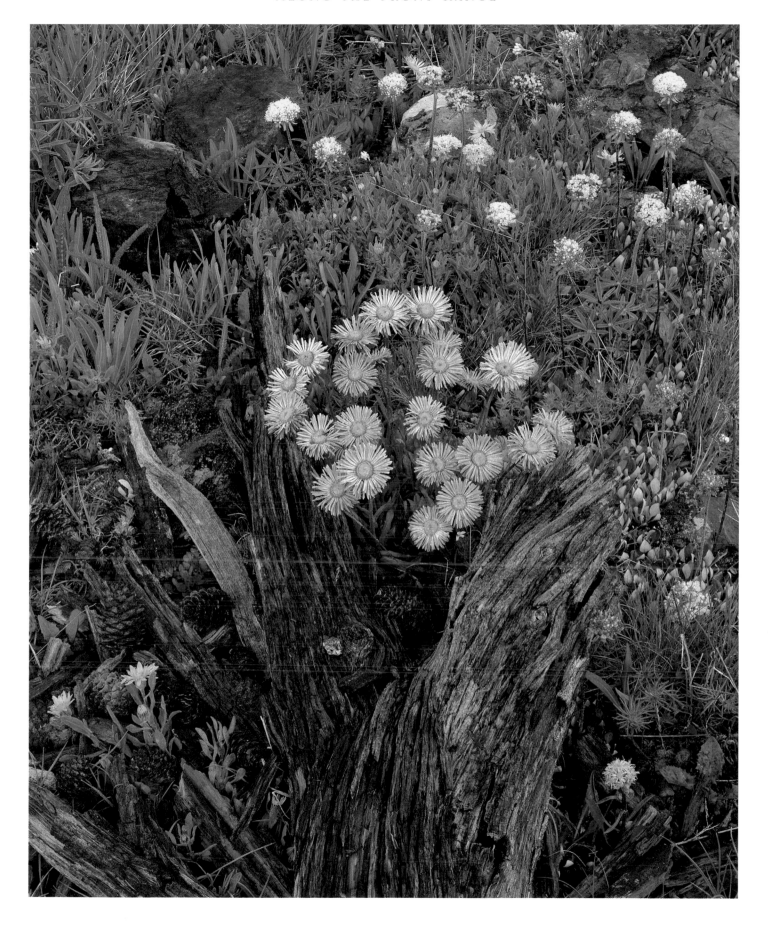

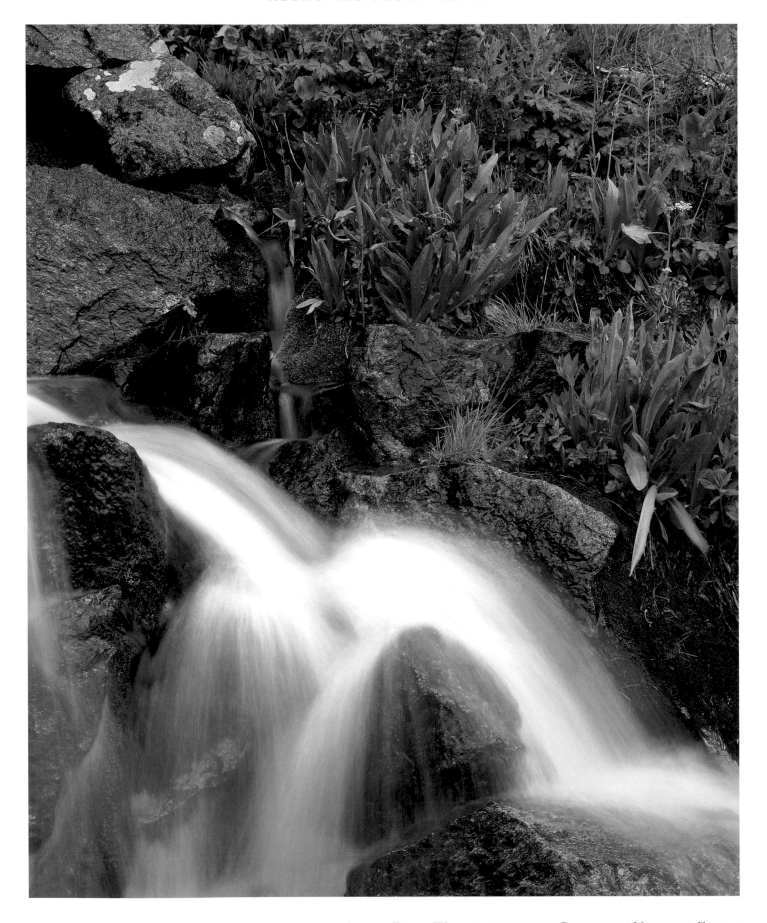

PARRY PRIMROSES BLOOM ALONGSIDE A STREAM IN THE INDIAN PEAKS WILDERNESS OF THE ROOSEVELT NATIONAL FOREST.

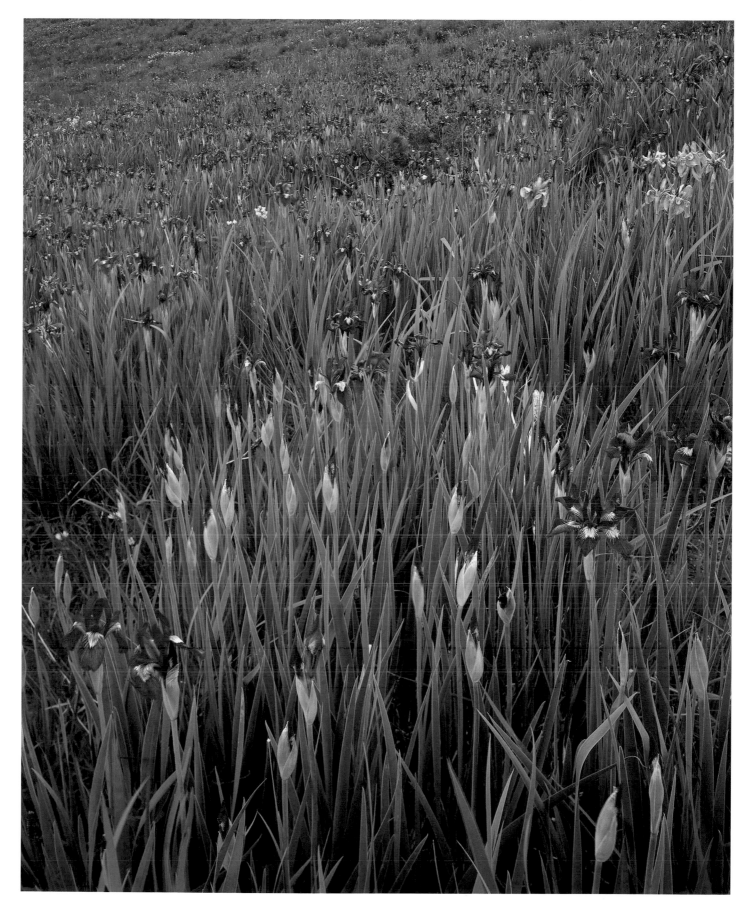

ROCKY MOUNTAIN IRISES COVER A MEADOW IN THE CUCHARA PASS OF THE SAN ISABEL NATIONAL FOREST.

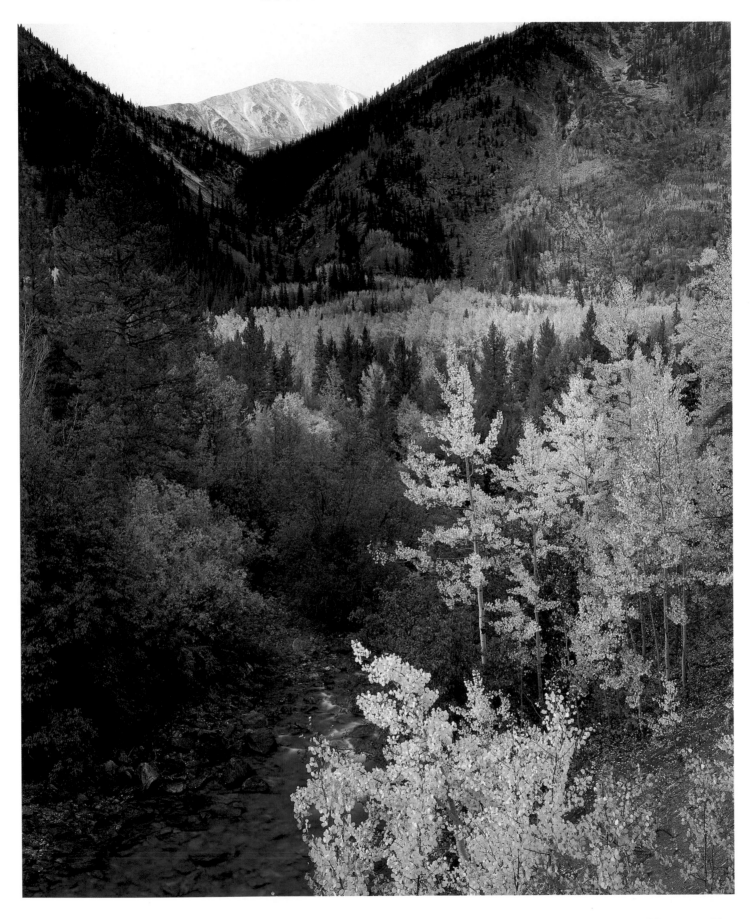

ASPEN TREES DISPLAY THEIR FALL COLORS ABOVE CLEAR CREEK IN CLEAR CREEK CANYON OF THE SAN ISABEL NATIONAL FOREST.

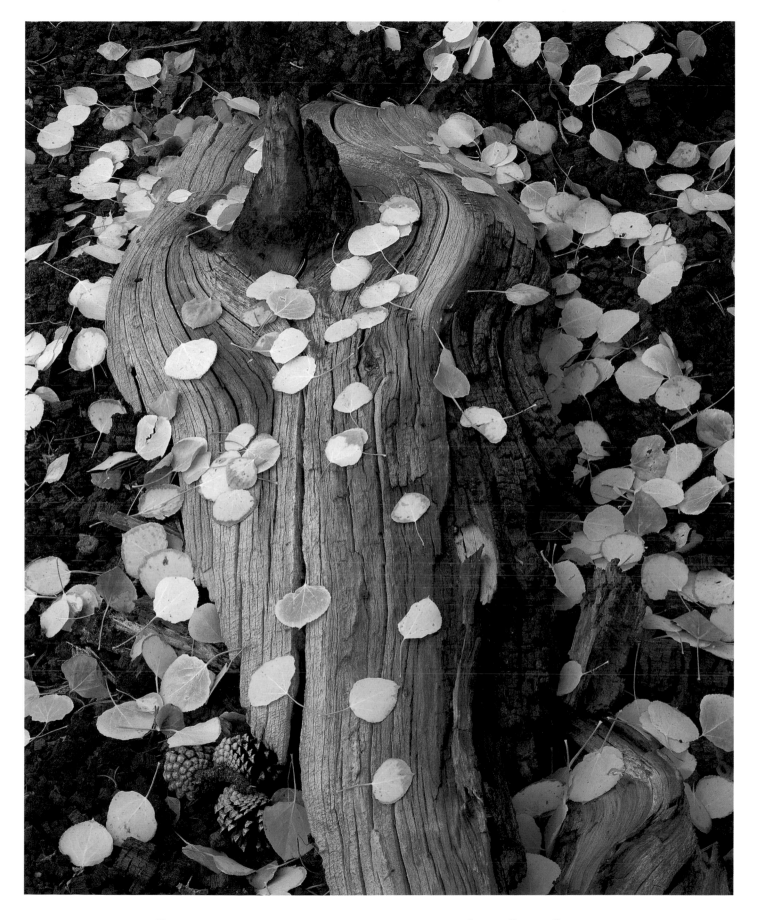

FALLEN ASPEN LEAVES BLANKET A LOG FRAGMENT IN CLEAR CREEK CANYON.

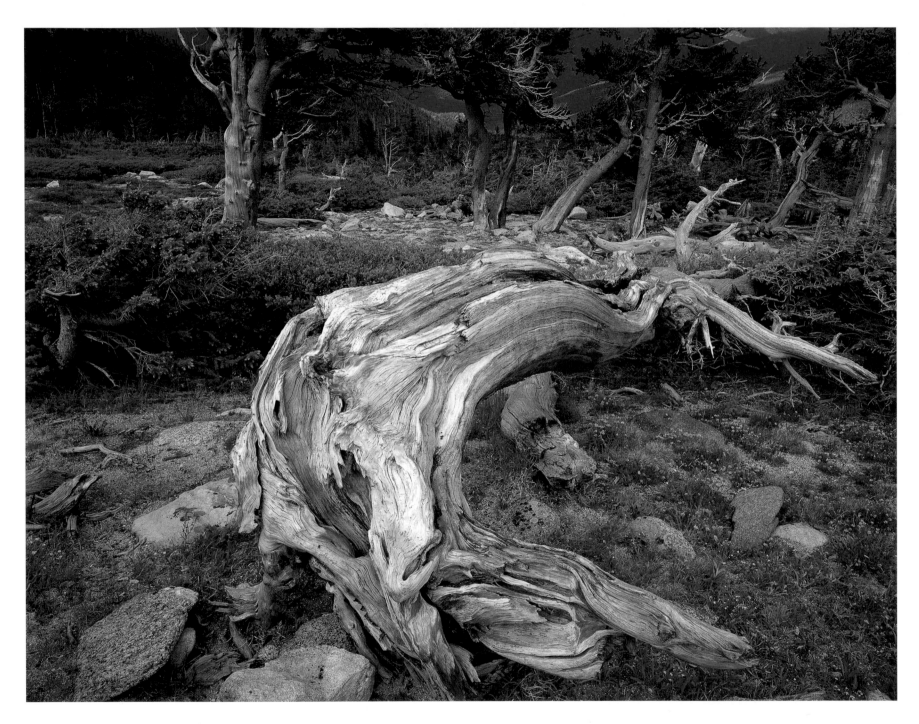

Bristlecone pines in Mount Goliath Natural Area in the Arapaho National Forest.

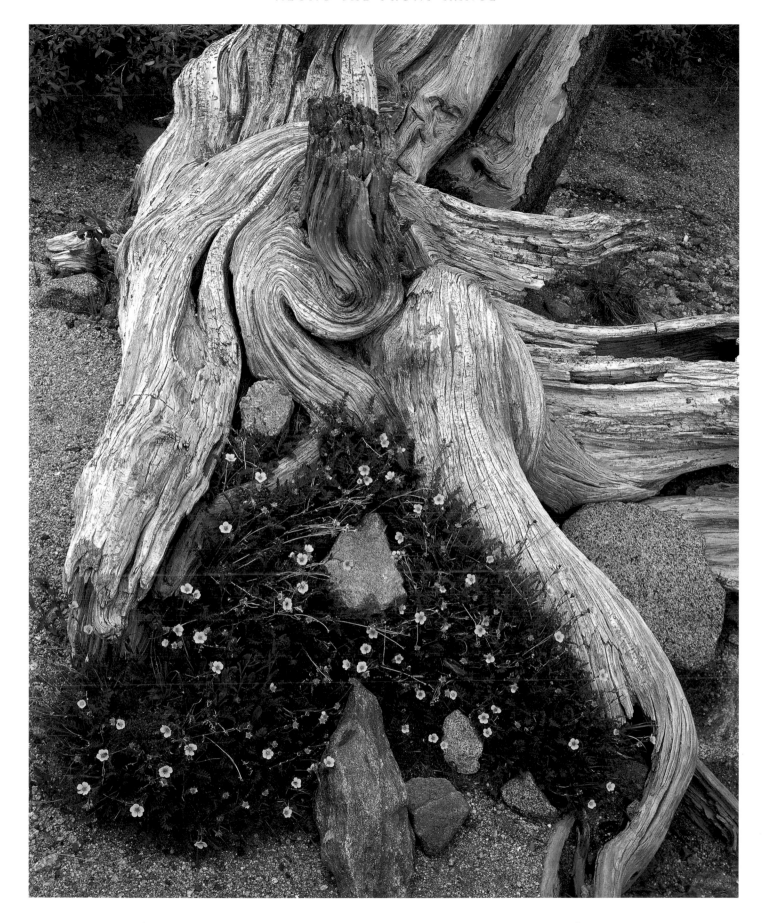

A PATCH OF ALPINE AVENS GROWS IN THE SHELTER OF A BRISTLECONE PINE'S ROOTS.

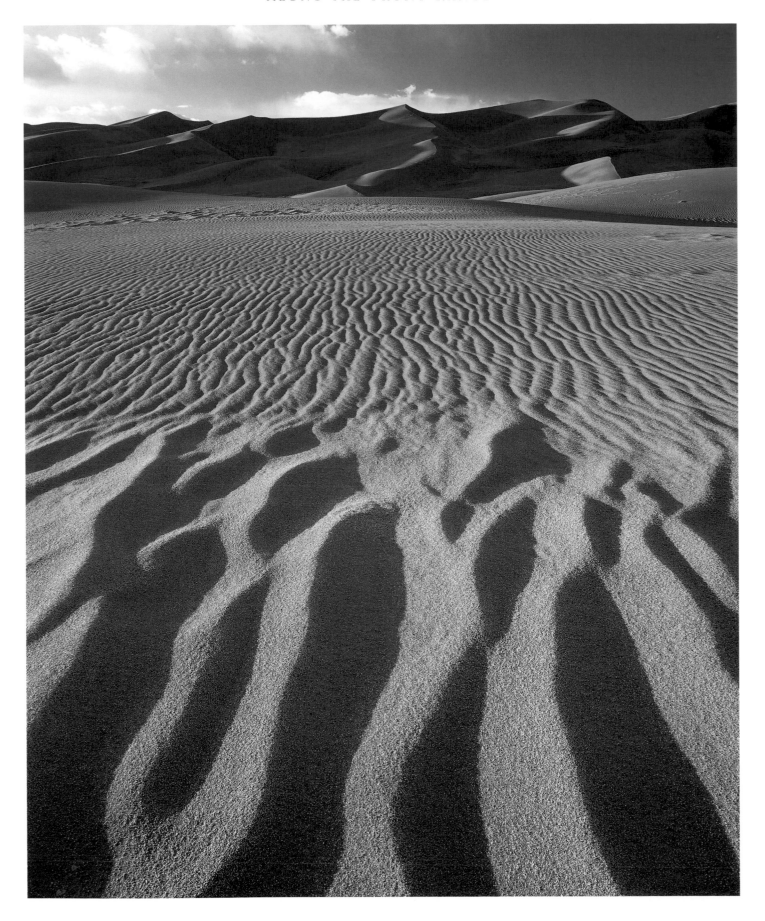

Evening sunlight shines on Great Sand Dunes National Park and Preserve.

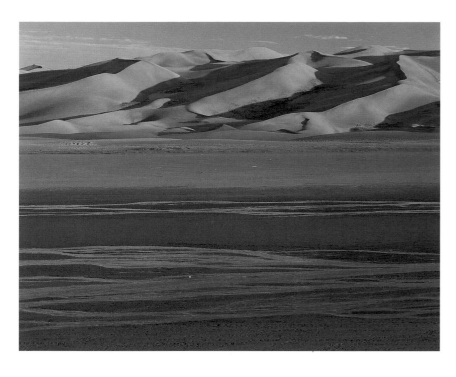
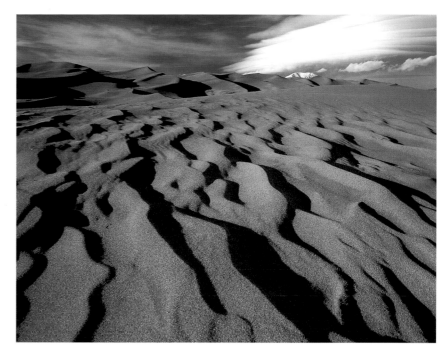
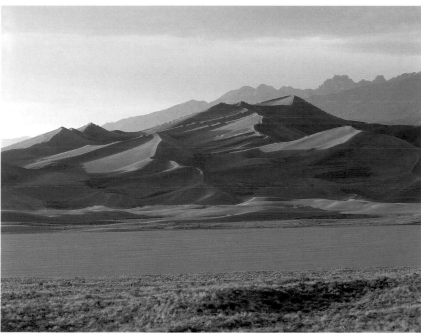
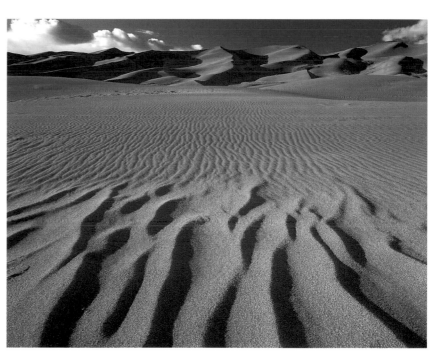

Sand formations in Great Sand Dunes National Park and Preserve.

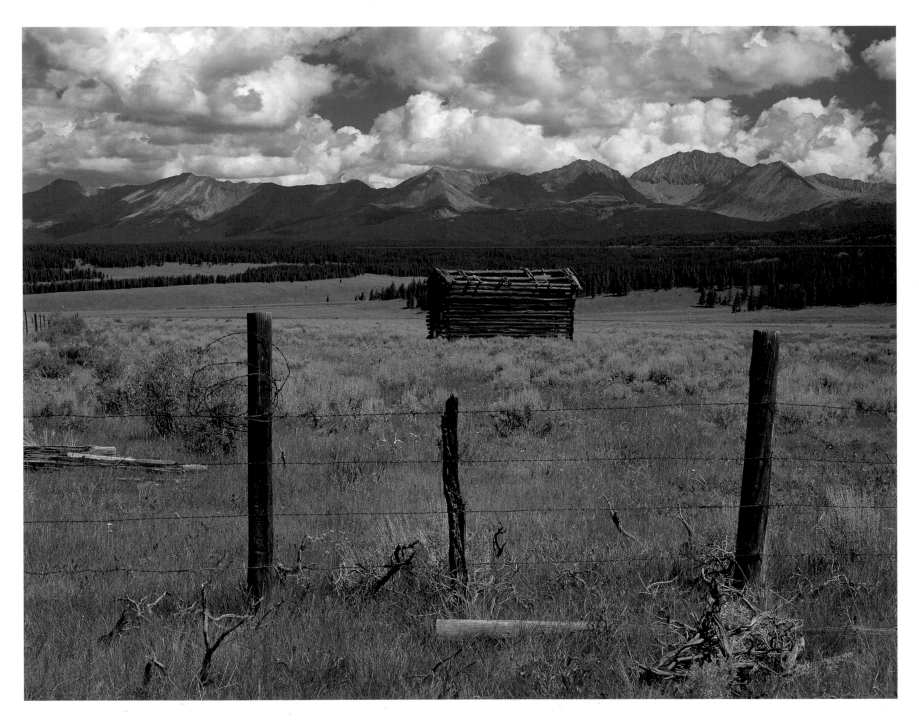

AN OLD CABIN ON THE PLAINS BELOW COLLEGIATE PEAKS IN THE SAN ISABEL NATIONAL FOREST.

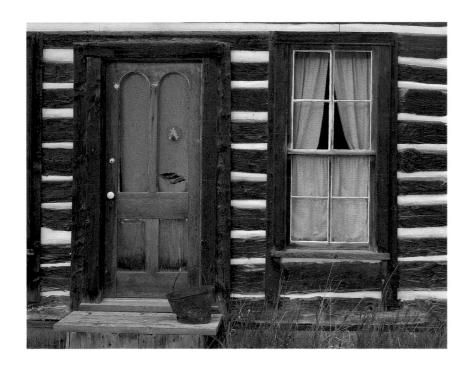

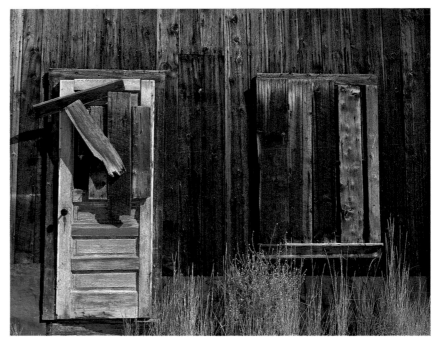

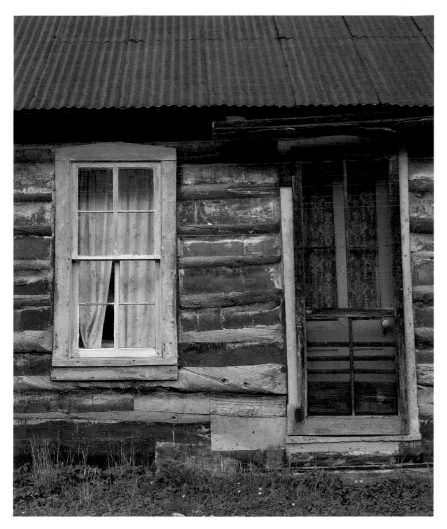

DOORWAYS TO THE PAST IN THE GHOST TOWNS OF
TINCUP AND ST. ELMO.

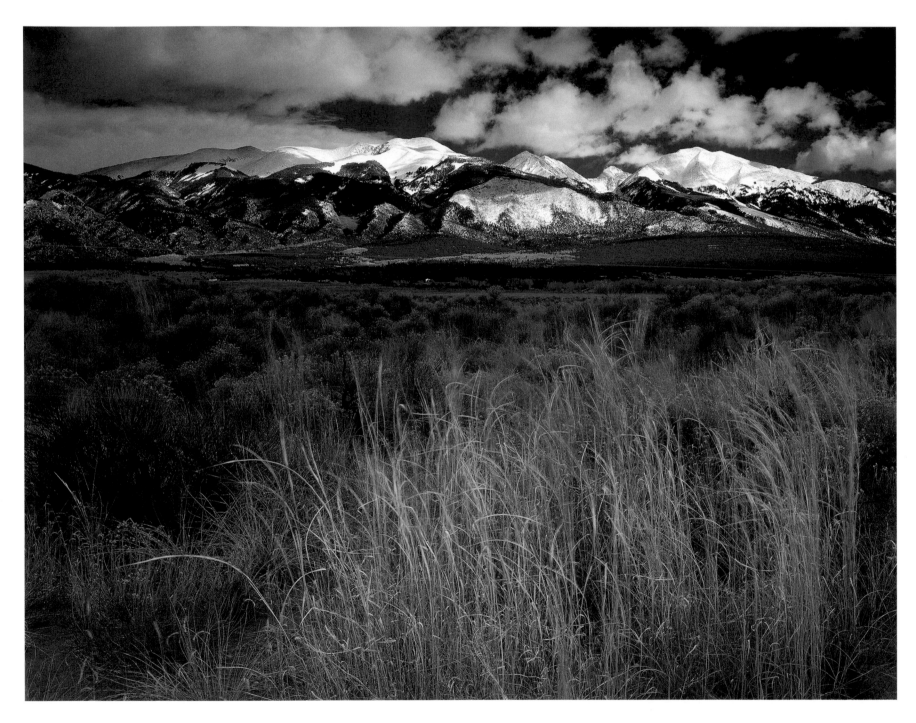

GOLDEN GRASSES BLOW IN THE AUTUMN WIND ON THE NATURE CONSERVANCY'S MEDANO-ZAPATA RANCH BELOW
BLANCA PEAK IN THE RIO GRANDE NATIONAL FOREST.

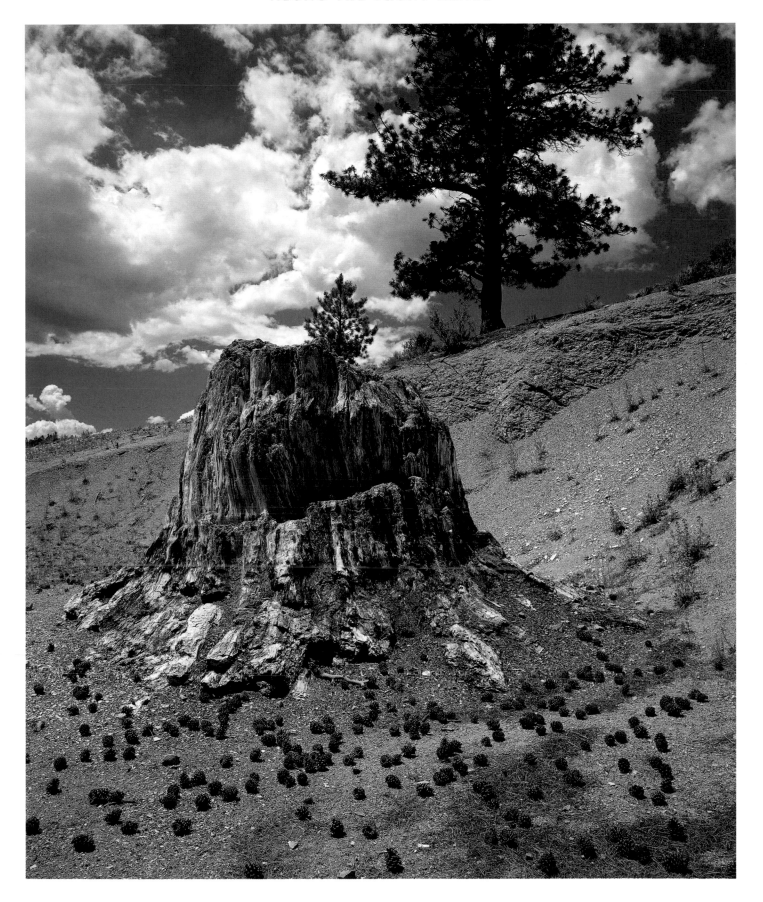

A PETRIFIED TREE STUMP IS SURROUNDED BY FRESHLY FALLEN PINECONES IN FLORISSANT
FOSSIL BEDS NATIONAL MONUMENT.

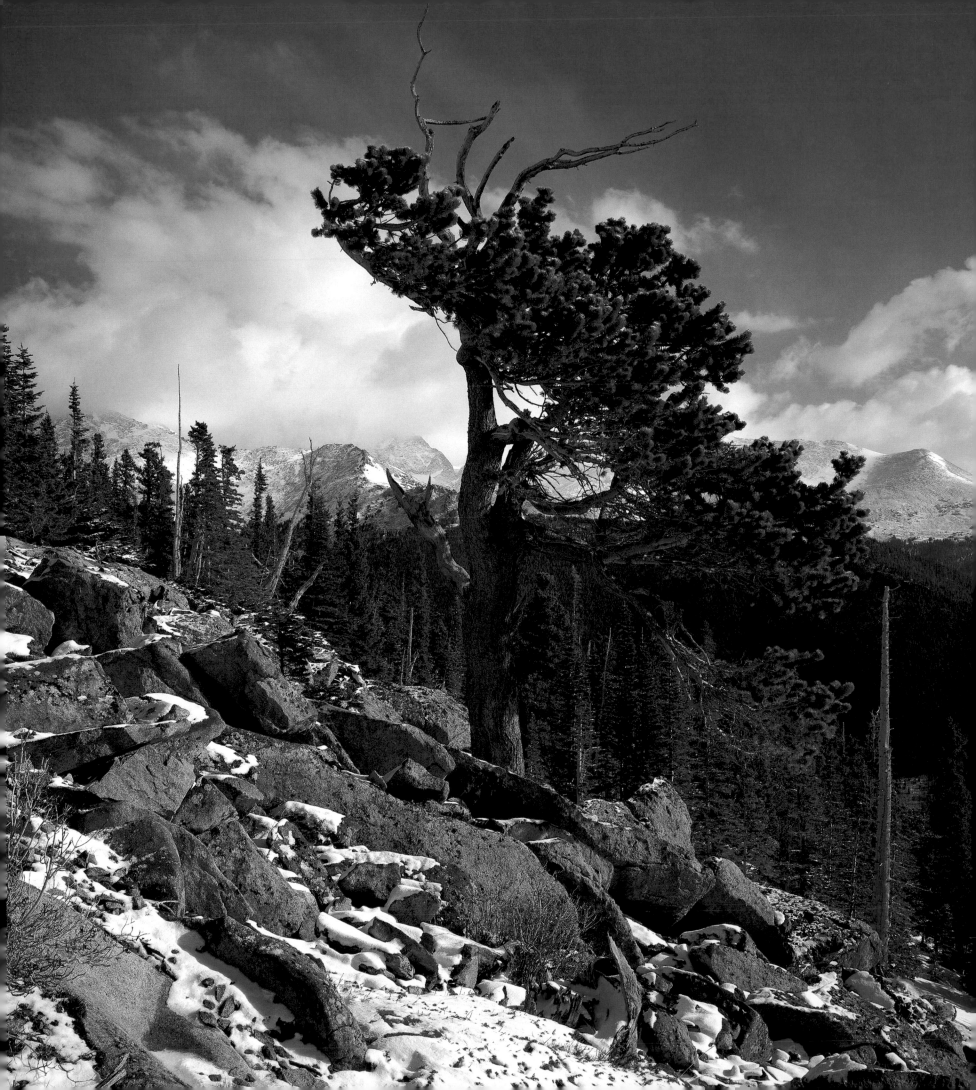

"We stood on the mountain looking down at the headwaters of Little Thompson Creek,
where the Park spread out before us. No words can describe our surprise, wonder
and joy at beholding such an unexpected sight."
—Milton Estes, "The Memoirs of Estes Park," *Colorado* magazine, July 1939

ROCKY MOUNTAIN NATIONAL PARK

A Crown Jewel Preserved

Milton Estes was not alone in his admiration for this magnificent natural landscape that would become Rocky Mountain National Park in 1915. William Henry Jackson came to photograph; Albert Bierstadt and a host of others came to paint. John Wesley Powell, the first to navigate the Colorado River through the Grand Canyon, also was drawn here and is credited with making the first successful ascent of Longs Peak—at least by someone of European descent.

From the early days of its discovery, this land of scenic grandeur, vistas, wildlife, flowers, and streams could not long remain in obscurity. Word of its awe-inspiring beauty spread quickly, far and wide. nature's bounty was so exuberant and so manifold that, unlike other mountainous regions of the state, it was explored, less for any precious metals that might lie waiting and more to experience its natural abundance.

Joel Estes, the first explorer to view the area, settled here with his family in 1860. "We were the monarchs of all we surveyed,

mountains, valleys and streams," wrote his son, Milton. "There was absolutely nothing to dispute our sway. We had a . . . world all to ourselves." Arapaho and Ute Indians, however, had hunted and camped in the region for many years. The first "road" from east to west was not the current, heavily traveled Trail Ridge Road but rather a well-worn footpath trafficked by Native Americans crossing back and forth in pursuit of game.

Wildlife has always been present in great numbers, drawn to the ample supply of food and water found in the river valleys and the protection the surrounding mountains offer in winter. Elk, bighorn sheep, coyote, foxes, snowshoe hare, and innumerable birds call Rocky Mountain National Park home.

I stand, watchful and unmoving one frosty evening, just at dusk at the edge of one of the park's meadows of lush grass and fingerling streams. The spires of tall spruce rim the area, quiet and dark. It is late September, the time of the bugling of the elk, when the bulls are in rut, and their eerie mating calls resonate through the valleys.

A LATE SPRING SNOW BRUSHES TRAIL RIDGE IN ROCKY MOUNTAIN NATIONAL PARK.

Time slips by and shadows lengthen. The silence grows heavy, almost unendurable. Then, like actors slipping onto a stage, the shadows take form, and without sound, small groups of cow elk emerge from the wings of this natural theater in the round. Shakespeare himself could not have staged it more dramatically.

The quiet is suddenly shattered as several bulls charge abruptly out from the trees, bellowing their arrival with a trumpeted fanfare that speaks of the primordial, a sound unchanged through the eons, beyond time and place. Pandemonium follows as the bulls seek to establish their primacy and to protect their harem from all interlopers.

It is a powerful, moving scene set against the calm of the pristine meadow. The intense pulse of nature and its gentle hand meet as one in this ancient, yearly drama that plays itself out as night falls.

The crowning glory of Rocky Mountain National Park rests, as all crowns should, on top—the top of the world, that is—above the highest trees and just below the clouds. This is the alpine tundra, a land of vast extremes: far-as-the-eye-can-see, panoramic vistas as a backdrop to thimble-sized plants with flowers measuring scant millimeters in diameter. It is at once sublime and surreal, a world of lichen-bejeweled rocks set in a patchwork quilt of elfin flowers.

To walk on the tundra is to walk on the footprints of the sky. Where one can witness the work of millenniums of time compressed into a landscape of wild and almost incomprehensible grandeur. Where glacier-scoured valleys, soaring mountains, and the forces of wind, water, and ice bear mute testimony to earth's slow, inexorable evolution.

Derived from a Russian word meaning "land without trees," tundra is found around the world, at Arctic latitudes and atop mountain ranges in the European Alps, Lapland, the Himalayas, and Iceland. To a striking degree, many of the same plants found on the park's tundra also grow in these other locales, the result of their post–Ice Age migration from the Himalayas, where they had originally developed, to similar, hospitable climes.

A world in miniature lies at my feet, and I pause in wonder, both at the delicate loveliness of the flowers and also at their amazing capacity to endure in such a harsh land. But for all their fragile demeanor, these plants are tough, with adaptations geared for survival in this extreme environment. All hug the ground, out of the wind, gleaning warmth from the heat of the earth. Many contain anthocyanin, a red pigment that tints the leaves and acts somewhat like anti-freeze, enabling them to photosynthesize at far lower temperatures than their sea-level relatives. Tundra plants grow in dense, tight mats or clumps, huddled close for warmth, while fine, soft hairs—a fur coat, in effect—protect the leaves. Many flowers are light sensitive, closing at night or on a cloudy day to retain heat.

The most arresting feature of the park, the mountain king rising above it all in unmatched splendor, is Longs Peak. It is of a scale that is both striking to behold and impossible to ignore. Wherever one wanders in the park, its presence dominates the landscape.

From its lofty height, soaring above 14,000 feet, Longs Peak is the sentinel that greets the dawn, its gray, granite features momentarily transformed by golden light. And, at the end of the day, it is the last to bid a high and final farewell to the fading glow of the sun. Watching a full moon rise behind its silvered face is a moment long to be remembered.

Major Stephen F. Long, charged with mapping the boundaries of the Louisiana Purchase, was the first American to "discover" the peak in 1820—although he never set foot in the park, viewing it only from a distance as he ventured along the South Platte River. But he left his name emblazoned on the landscape, as did others—soldiers, scientists, and settlers—who explored the state and live on in the place names of rivers, mountains, and plants, indelible reminders of those first intrepid souls who ventured west.

Even though John Wesley Powell is generally credited with the first successful ascent of Longs Peak, Arapaho Indian accounts from the early twentieth century tell of a tribesman named Old Man Gun who regularly climbed it to trap eagles on the summit. There would be plenty of room on top for such activity as the expanse on the rock-strewn summit measures over four acres.

Winter brings calm and renewal to the park. Heavy snows blanket the area, obscuring all traces of human presence. Elk and bighorn sheep descend into the valleys seeking a more plentiful supply of food. Ice fills the streams, inhibiting their flow and muffling sounds. A silence falls over the land, and once again the park settles into a life little changed since Joel Estes first happened upon it in 1859.

Exploring the park in the winter requires skis, and as I strap them on, I think of the advantages this mode of transportation offers. Instead of racing through the park in the insulation and isolation of a car, the slower pace of skis allows for a much more complete experience, exposing all the senses to the spirit of the land.

Bits of snow, shining like crystals, hang in the air on this blue-sky day as we traverse the valley. Tiny animal tracks are imprinted everywhere, seeming to lead nowhere: over a rock, under a log, turning back on themselves, suddenly disappearing. We stop to ponder whose footprints they might be, but I've never been any good at identifying tracks. The snow exaggerates their size, and what I think might be a weasel is probably only a mouse.

We see no one as we climb higher and higher. The silence is so profound that when a raven flies near us, the sound of its powerful

wings resonates in the air. As if to proclaim that this is his territory and not ours, he hails us with a loud *caw* as he passes overhead, rising upward with the thermals.

We are near timberline, following an old road. The wind has carved and sculpted the snow into fascinating, patterned surfaces, snowballs, ridges, and drifts. Suddenly one of those snowballs moves slightly, and we stop, puzzled. More movement, and to our astonishment a pair of red eyes gaze, unblinking, back at us. For this snowball is alive and not a snowball at all, but a white-tailed ptarmigan, a grouse-like bird that spends the winter on the tundra. Totally white except for the eyes, it blends imperceptibly into the snow.

Well equipped for survival, the ptarmigan has extra feathers growing between its toes for warmth, making it look like it's wearing snowshoes. Unable to fly at great heights or distances, it relies heavily on its coloration for protection, and rightfully so, since we would never have seen it if it hadn't moved. In the summer, trading its winter coat for a mottled camouflage of brown flecked with white, it lives among the rocks and willows on subalpine slopes.

The ptarmigan, the call of the elk each fall, the immutability of the mountains—all provide a certain reassurance for me in this twenty-first-century world where change is the accepted axiom. But here, change is the exception, not the rule: the ptarmigan, year after countless year instinctively in rhythm with the seasons; the elk, players in an age-old ritual; and the mountains themselves, timeless and enduring.

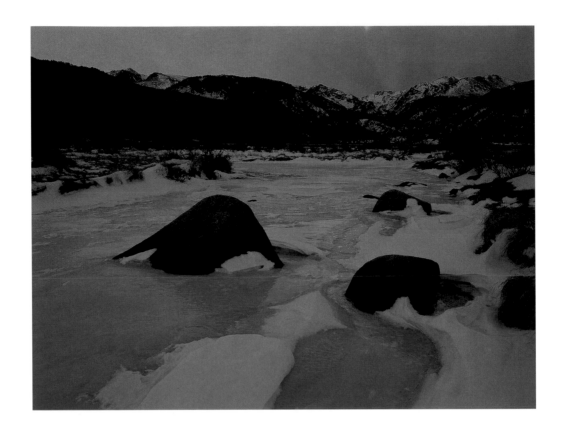

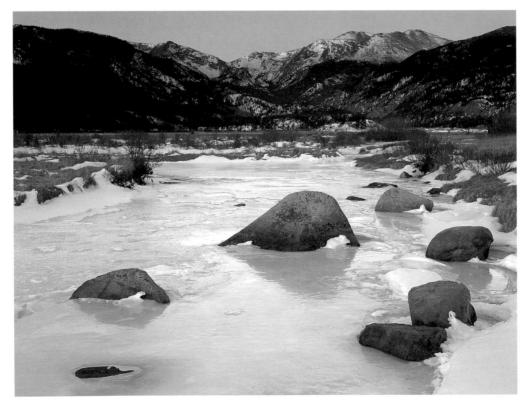

LIGHT FROM DIFFERENT TIMES OF DAY AND PASSING SEASON PLAYS ON BIG THOMPSON CREEK IN MORAINE PARK, ROCKY MOUNTAIN NATIONAL PARK.

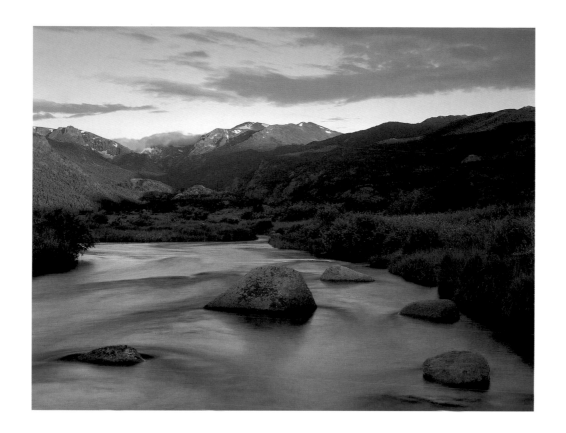

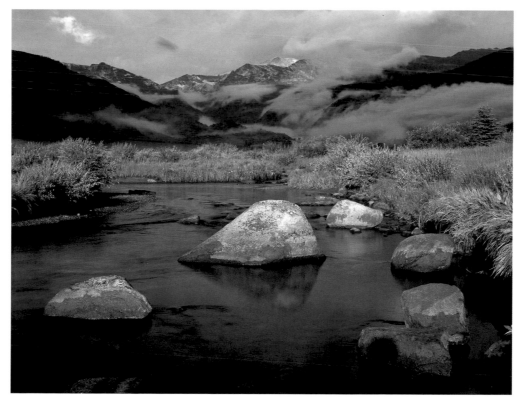

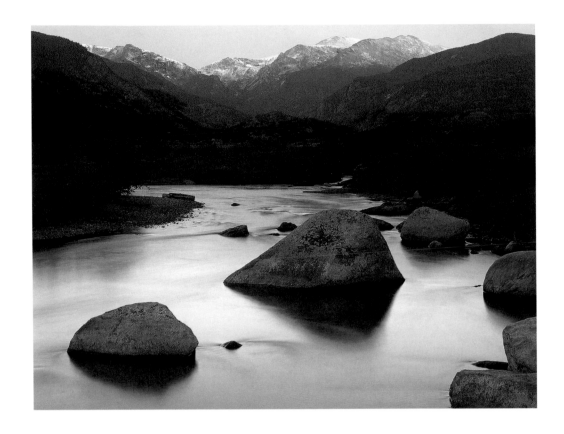

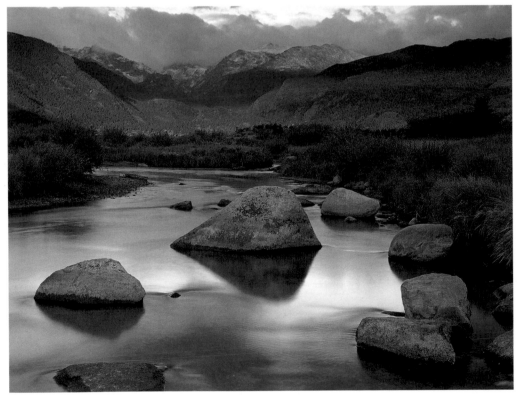

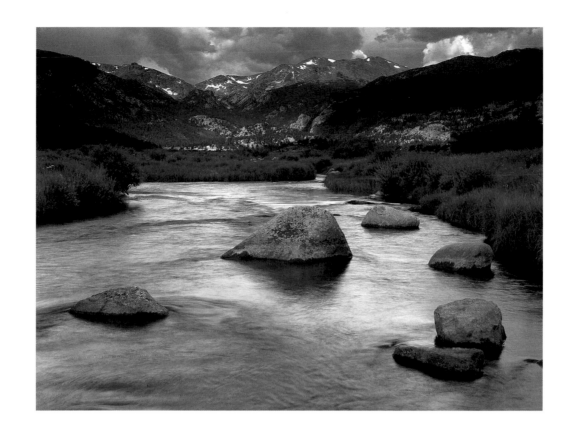

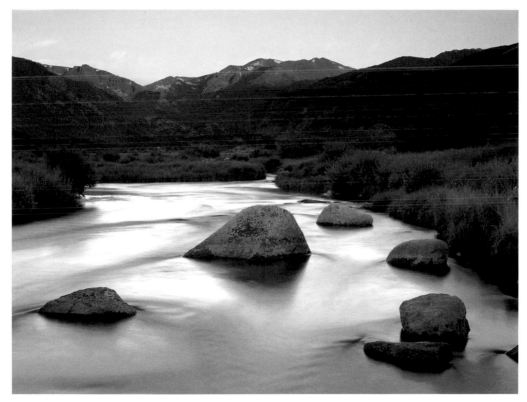

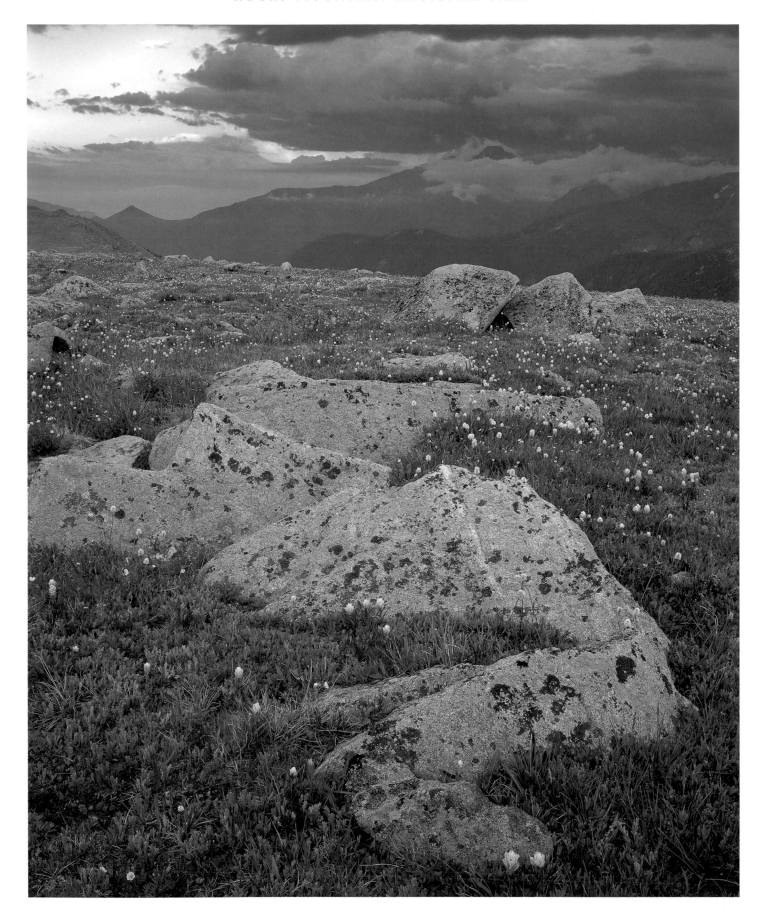

A STORM CLEARS OVER LONGS PEAK IN ROCKY MOUNTAIN NATIONAL PARK.

WHIPROOT CLOVER GROWS IN THE TUNDRA ATOP FALL RIVER PASS IN ROCKY MOUNTAIN NATIONAL PARK.

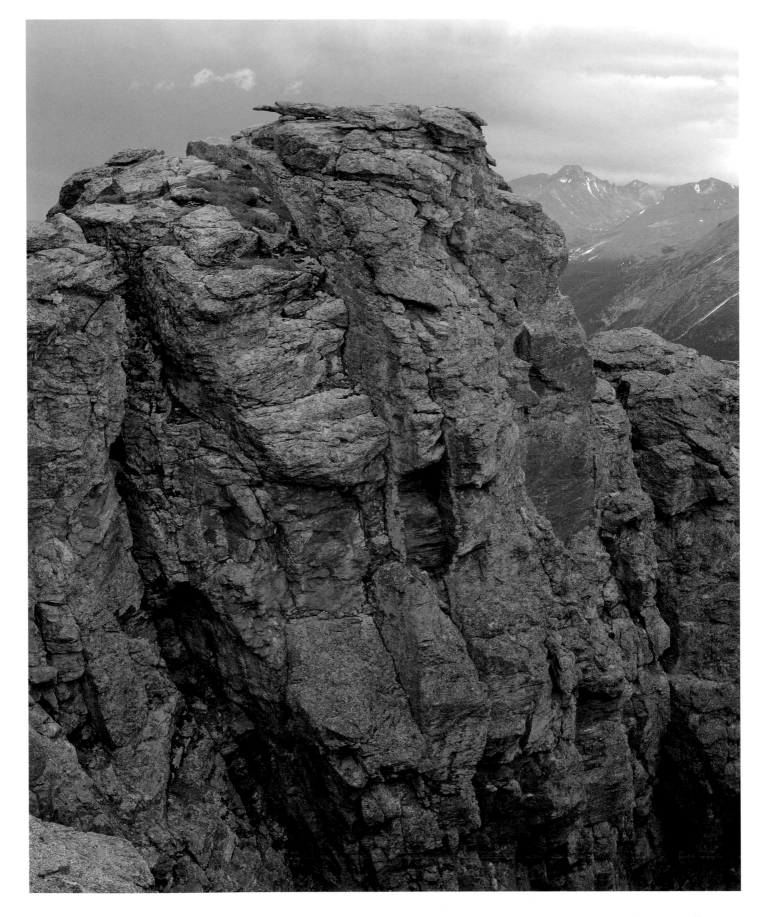

A LICHEN-COVERED ROCK FACE JUTS OUT OF ROCK CUT BELOW LONGS PEAK IN ROCKY MOUNTAIN NATIONAL PARK.

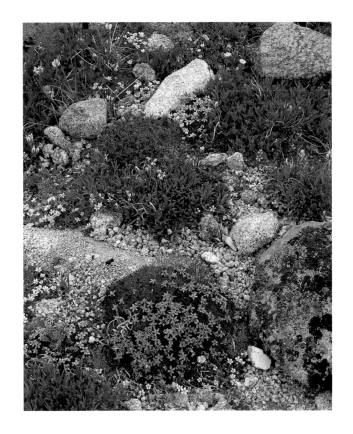

MOSS CAMPION.

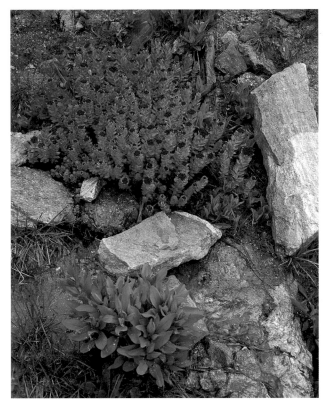

KINGS CROWN.

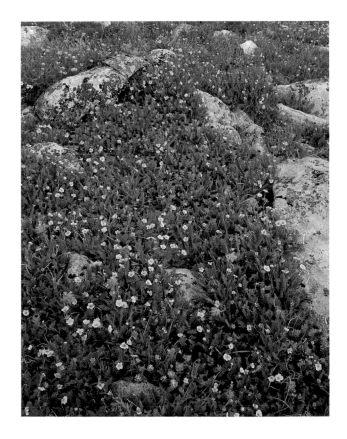

ALPINE AVENS AND KINGS CROWN.

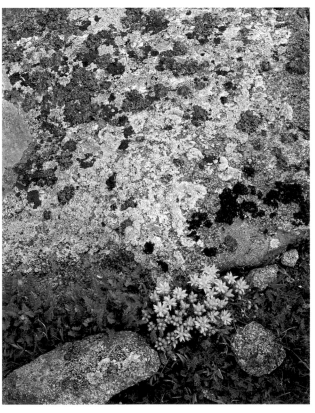

YELLOW STONECROP AND LICHEN.

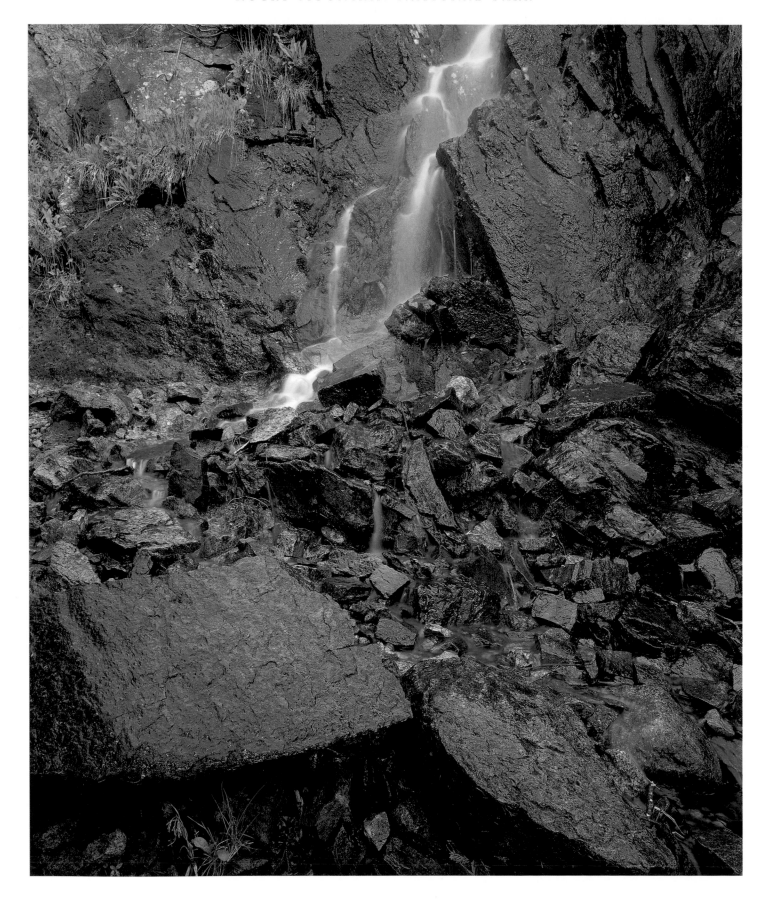

A MOUNTAIN SPRING TUMBLES INTO A WATERFALL NEAR BLACK LAKE, ROCKY MOUNTAIN NATIONAL PARK.

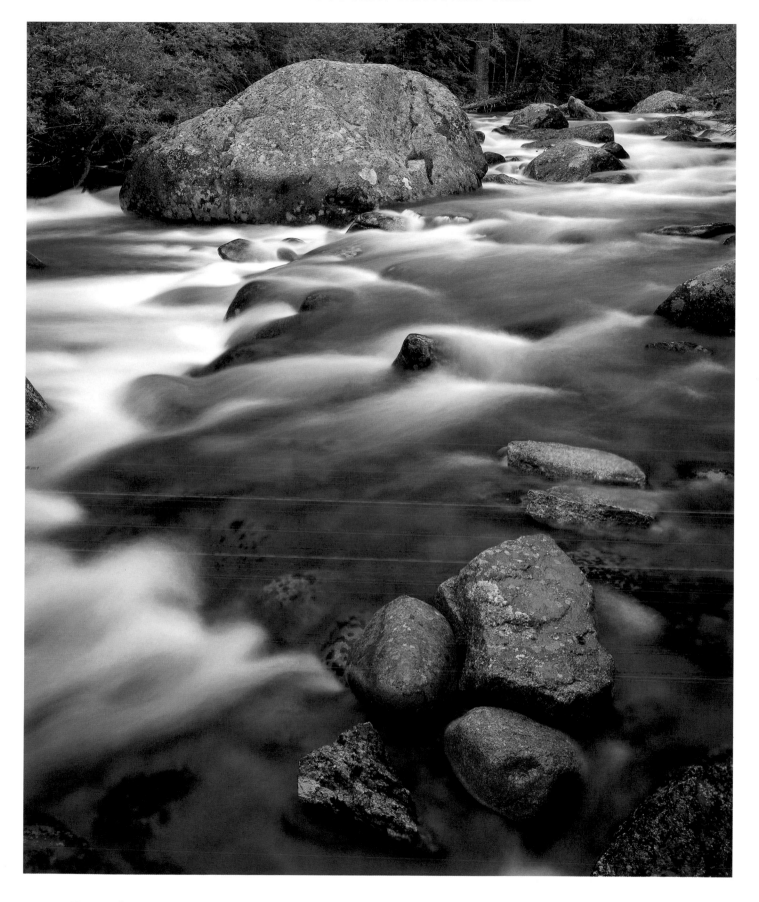

NORTH ST. VRAIN CREEK FLOWS SMOOTHLY AROUND LICHEN-COVERED ROCKS ON ITS WAY TO COPELAND
FALLS IN THE WILD BASIN NATURAL AREA.

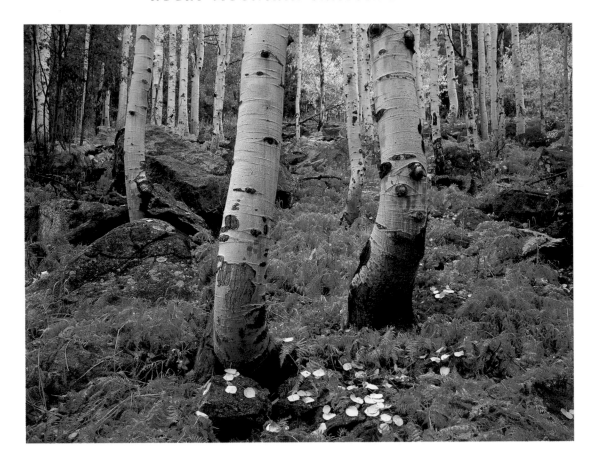

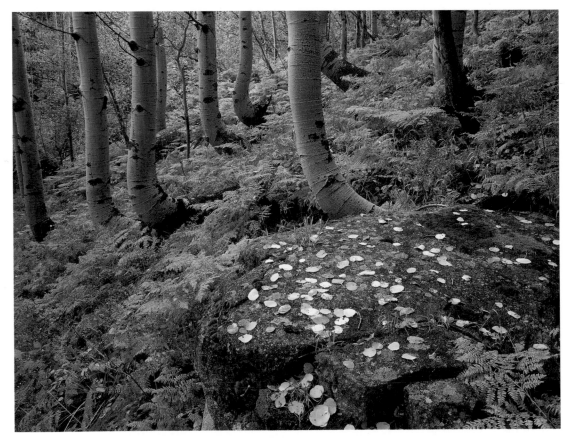

ASPEN AND FERN SHOW THEIR AUTUMN COLORS.

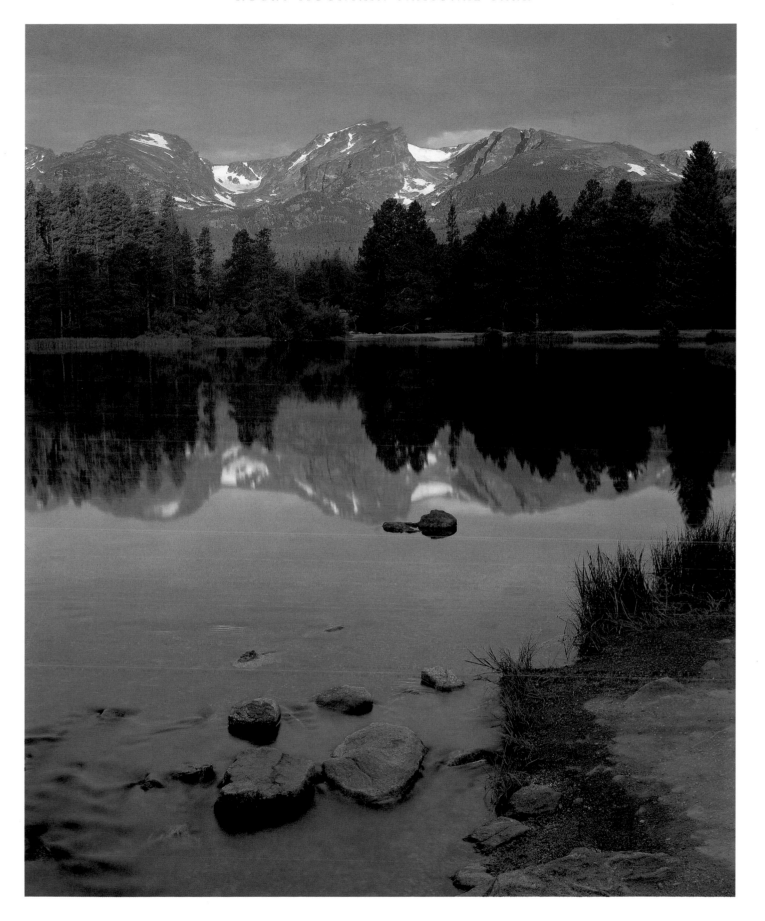

THE SUN'S FIRST LIGHT SHINES ON HALLETT PEAK ABOVE SPRAGUE LAKE IN ROCKY MOUNTAIN NATIONAL PARK.

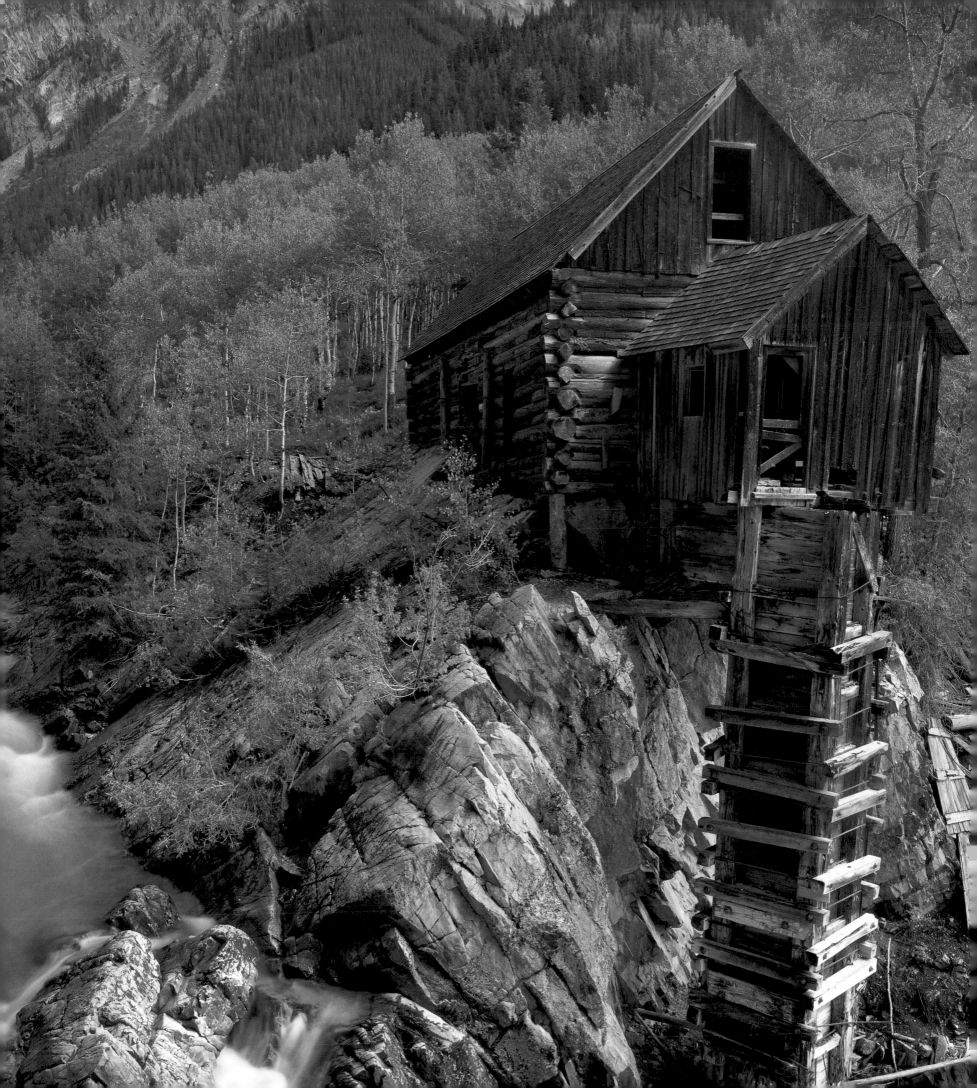

"The mountains speak in wholly different accents to those who have paid in the service of toil for the right of entry to their inner shrines."
—Sir Arnold Lunn

INTO THE HIGH COUNTRY

Across the Divide to the Western Slope

As a child I stood beside my brothers at a roadside marker designating the location of the Continental Divide in Yellowstone National Park. Laughing and elbowing each other for just the right position, we straddled that imaginary line, planting one sneaker-clad foot with exaggerated precision on its west side and the other on the east. Afterwards, back in the car and counting bears—our main preoccupation of the day—I struggled to understand, with a nine-year-old's comprehension, the marker's significance and to imagine the immense, divergent journeys that raindrops falling only inches apart on that high, rocky ridge would take on their way to opposite oceans thousands of miles apart.

I'm a lot older now, but that feeling of awe has remained, for the Continental Divide is the great defining element not only of Colorado but of the North American continent as well. Following a high, sinuous course through the heart of the Rockies, its powers of separation are absolute. In Colorado, all water to the east flows to the Gulf of Mexico; to the west, it makes its way into the Colorado River, which then courses for more than a thousand miles before eventually emptying into the Gulf of California.

The Divide is the key to precipitation in the state as well, its towering height posing a major barrier to moist air blown inland from the Pacific Ocean. With nowhere to go against this impenetrable rocky fortress, humidity-laden winds are forced upward, releasing moisture as they struggle to rise over the mountains. Three quarters of Colorado's annual precipitation falls west of the Continental Divide, the arid plains to the east thus enveloped within its rain shadow. Most snow and rainfall occur on the Western Slope during the winter months, while to the east, the spring months are the wettest.

On the eastern side of the Divide, air from the Gulf of Mexico sweeps in on spring winds from the east and south, slamming against the Front Range and bringing fog and snow that can linger for days. At such times Denver and Colorado Springs, lying along the edge of the mountains, may be totally socked in, while communities just a few hundred feet above bask in blue skies.

THE REMAINS OF THE HYDROELECTRIC POWER GENERATOR FOR THE OLD CRYSTAL MILL CLINGS TO A ROCKY CRAG ABOVE THE CRYSTAL RIVER.

Northwest of Boulder, the Continental Divide loops briefly toward the east, sending powerful winds spawned at high altitudes funneling down through eastern canyons and valleys. Blowing with unbridled fury along the foothills, such winds are commonly clocked at more than 100 miles per hour.

Native Americans camped and hunted for thousands of years through Colorado's mountain regions. Early trappers came for beaver and other pelts, but it was nineteenth-century prospectors, lured by a siren's call of gold and silver, who led a stampede to timberline and were the first to leave permanent marks of civilization upon the high country.

Gold fever—an incurable malady fanned by whispers, hunches, and intrigue—spread throughout the West in epidemic proportions from the moment the first few nuggets were found in a stream in Sutter Creek, California, in 1848. In Colorado, remnants of those early days are sprinkled throughout the mountains, silent testaments to a time of high hopes and unrealized dreams: an isolated, wind-scoured cabin high up a narrow trail, abandoned slag heaps wrung from the mountain's core, and hastily constructed towns, now weathered to a silvered hue, where today only ghosts abide.

A capsule history of the town of Tincup is perhaps typical of many of these boom-and-bust communities: Dwellings sprung up overnight, constructed by miners dazzled by a few promising nuggets of gold in nearby streams. Law and order was anything but—seven town marshals were killed in a few short months. There were many saloons but few churches. The only access was via a rough stagecoach ride in the summer or by a tortuous, freezing journey on skis in the winter.

Hopes were high and rumors abounded: The railroad was coming . . . well, no, it wasn't. A million-dollar strike had occurred just over the hill . . . well, no, it didn't pan out, literally or figuratively. Broad "avenues" were laid out through the town, optimistically named Grand and Washington. All mining activity halted once a year for the annual Christmas dance where miners appeared, decked out for the occasion, in starched shirts and tails. But, alas, there were few women to appreciate their efforts. The town doctor was killed when his beard caught on fire while he was smoking in bed.

Tincup was the largest community in the county in the 1880s but stood virtually abandoned twenty years later. Here yesterday, all but gone today as it slips imperceptibly away to become, once again, one with the earth.

One tawny-gold September day I hike up a timber-lined path hewn from the wilderness well over a hundred years ago, a trail that offers poignant glimpses into the lives that were spent there. A rough, hand-carved stone in a glen of tall spruce trees marks the tiny, forlorn grave of William Huffman, a victim of deadly pneumonia when he was one month old. His father was a miner; his mother ran a nearby boarding house. Farther ahead is a roofless log cabin, home of Joe Anderson who built it along with the nearby Tip Top Mine around

1879. I ponder these lives as I walk along: the utter devastation of losing a baby, the isolation and physical hardships endured by the miner in his high, lonely cabin.

A mountaintop or two away from Tincup, I stand high above tree line early on a July morning on the slopes of Tabeguache Mountain. My son and I began hiking at sunrise, intent on climbing Tabeguache and Shavano, two of Colorado's lofty 14,000-foot peaks. But now, with uneasy eyes, I watch a fast-moving storm from the west closing in on us.

Summer thunderstorms usually build over the course of the day, bringing rain and lightning in early afternoon, so the timing of this one puzzles me. Retreating to a lower altitude is probably the saner alternative, but I can't see any lightning, and we are reluctant to give up our hard-won altitude. The storm sweeps forcefully over us, a sheet of rain, hail, and wind. Just as quickly as it had arrived, it passes on, bestowing on us a truly wondrous gift: a rainbow that, given our high mountain perspective, seems to stretch from one end of the world to the other. Far off to the west, the colors of a second rainbow echo in response. It is an amazing combination of awesome power and great beauty, a rare and sublime moment that will always abide with me, tucked away. Instead of fear, I feel privileged to have been a witness to nature's stunning, extravagant capriciousness.

The mountains are the obvious topographical features in Colorado that speak to its evolution; but perhaps it is water and ice and the effects of their continual etching, eroding, carving, and polishing that best give me a sense of the story that time has to tell, the eons involved in the creation of the state's present-day landscape. The evidence is everywhere—from valleys scooped out by ancient glaciers, to deep river-canyon walls scoured out by fast-moving waters, to the symmetrical roundness of river rocks made smooth by time and current.

Water is the major connecting element between the high country and the canyons and prairies lying far below. The rivers of Colorado are birthed in high, glacial, bowl-shaped cirques, their origin in seeps, rivulets, fens, springs, and melting snowfields. They flow into one another and coalesce to forge watery pathways down steep slopes, winding through mountain meadows, and carving out canyons before eventually spilling out onto the plains.

The flow and pace of a Colorado river as it heads downward varies greatly, depending upon the steepness of the terrain and the volume of water. It flings itself pell-mell down a boulder-strewn course, or meanders through a high meadow, carving out big, tranquil, looping oxbow bends. It generates powerful falls as it rushes almost vertically down a steep stretch, or patiently etches through ancient rock walls to create narrow, spectacularly beautiful canyons.

Just as the coursing varies, the many moods that a river evokes as it flows along also vary. Somber, laughing, still, ominous, cold, languid, bubbling, merry, energizing—a river's personality is a will-o'-the-wisp, ever changing, ever engaging.

Sit quietly by a stream or a pond in a high meadow and simply look and listen. Look for the signature plants that prefer damp feet—marsh marigolds, ladies tresses, globeflowers, brookcress, sky-blue chiming bells, and freckled-face monkey flowers. It's a busy world along a stream with butterflies on the wing, water sprites skipping over the water on long, skinny legs, bees intent on nectar gathering, and dippers searching below the surface for aquatic insects.

Listen for the music played by dancing water on its instruments of rock and stone. Revive your toes—and your spirits—in the ice-cold water. Lie against the sun-warmed, grassy carpet and inhale its delicious, earthy smell.

Below Tincup, the Taylor River runs through a rock-strewn, narrow canyon to emerge in one of Colorado's fabled lush valleys, at the head of which lies the town of Crested Butte. It is here, for me, that the heart and the land are one.

The mountains are not quite as high—in the 12,000- to 13,000-foot range—and like their neighbors that gaze down upon nearby Aspen, the peaks are composed of richly hued, sedimentary rocks in tones of bronze, rose, and umber. This mosaic of color sandwiched between the emerald green of the valley floor and the intensely blue sky above creates a land that one does not soon forget.

The region is amply graced, with year-round abundant moisture providing a densely carpeted, summertime mosaic of wildflowers. Blooming in grand profusion, an amazing kaleidoscope of color, shape, and form weaves among the aspens and saunters down the hillsides. On the wide valley floor, two of the state's loveliest rivers—the East and Slate—wend their way.

The area has long been explored for the many minerals contained within the surrounding mountains, but the brightest gem of all is the sublime loveliness of the area itself. Jeep roads following geologic faults honeycomb the terrain high and low, granting access to mining ghost towns, remote valleys, wildflower meadows, and sublime vistas.

Many of Colorado's mountain passes were named by early-day miners and bear fanciful titles: Frigid Air, Mosquito, Oh-Be-Joyful, Hoosier (so named by a homesick Indiana miner), and Electric (known for its lightning storms). Others bear the name of early prospectors, such as Taylor and Schofield Passes.

Having your name attached to Schofield Pass would be a dubious honor since it is one of the most infamous passes in the state. Out of Crested Butte, the road rises steadily, skirting the Mount Crested Butte ski area and winding up the magnificent East River Valley. Still gaining altitude, it eases through the ghost town of Gothic and on past Emerald Lake. Then, after fording Crystal Creek, the road starts downhill in an extremely steep decline along the surging Crystal River. On one side, steep canyon walls hem in the narrow road. On the opposite side a long, long drop-off descends into the river gorge below.

Years ago, I lost my nerve as the family Jeep was jolting down the steep incline. Grabbing the hands of our two small children, I announced that we would walk instead. And walk we did, leaving my husband behind to navigate the fearsome road. We carefully threaded our way above the churning river, caught up in the thunderous sound of an enormous rush of water pouring downstream over immense boulders left behind thousands of years ago by retreating glaciers.

Further downstream is the site of a well-known old mill perched precariously above the Crystal River. In reality a generator for power for the nearby mines rather than a mill, it was designed and built in 1893 by the proprietors of the Sheep Mountain Mine to aid in the extraction of zinc, lead, gold, and silver. A fine white stone, Yule marble, from the nearby town of Marble was used in the creation of the Lincoln Memorial and the Tomb of the Unknown Soldier.

To the west and southwest of Crested Butte lies the stunning landscape defined by the West Elk Mountains. Volcanic fire and the erosive forces of ice and wind have crafted wide valleys of aspen and flower-strewn meadows. Towering, fortress-like spires edge the region, guardians protecting the natural world that lies shadowed below. The neighboring Ruby Range is set afire by the late afternoon sun, a brilliant alpenglow that is an ironic reflection of the minerals encased within.

The West Elks were created by the same pattern of uplift, volcanic action, and erosion as the neighboring San Juan Mountains to which they were originally joined. Uplift has exposed beautiful coloration in the sedimentary rocks while glacial activity scoured out gentle, U-shaped valleys below. Wind and water did the rest, etching out streambeds, waterfalls, and precipitous canyons and sculpting striking rock formations.

Many other regions of the world have undergone geologic transformation similar to Colorado's, with uplifted mountains and twining canyons. But two factors make Colorado's landscape unique: Unlike a rainforest, where vegetation covers and obscures the terrain, the mountaintops here are above tree line, free of dense vegetation, thereby exposing fantastic rock outcroppings. In canyons and along rivers, the cold, arid, windswept climate and poor, shallow soil preclude lush growth, placing their craggy beauty on display as well. An additional factor, and one that accounts for much of the startling beauty of the landscape, is the highly colorful, multi-hued mineral content of the exposed rock.

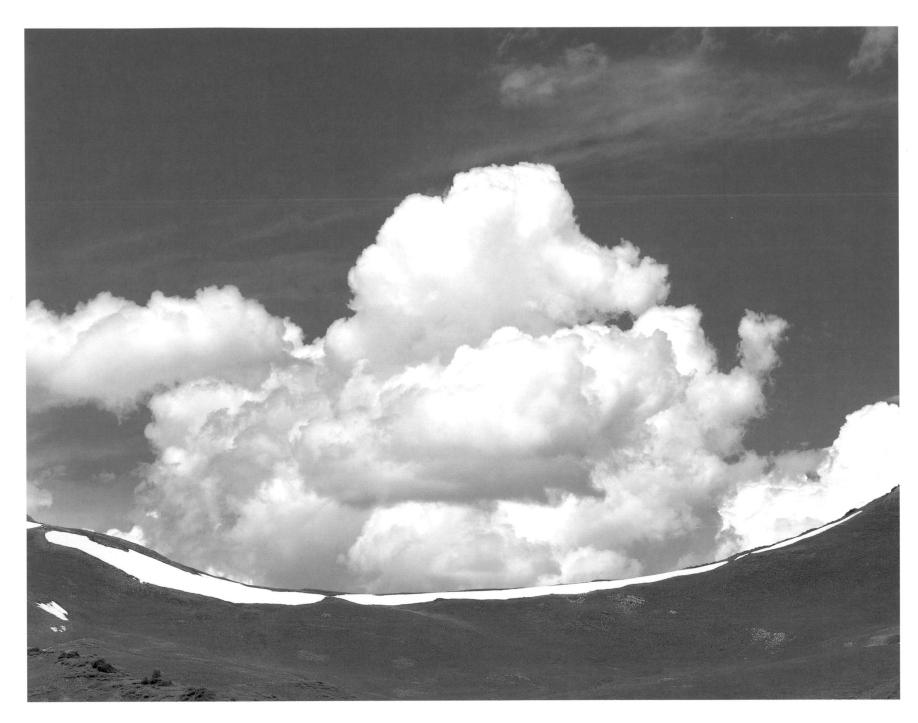

CLOUDS BUILD OVER FRIGID AIR PASS IN THE MAROON BELLS–SNOWMASS WILDERNESS.

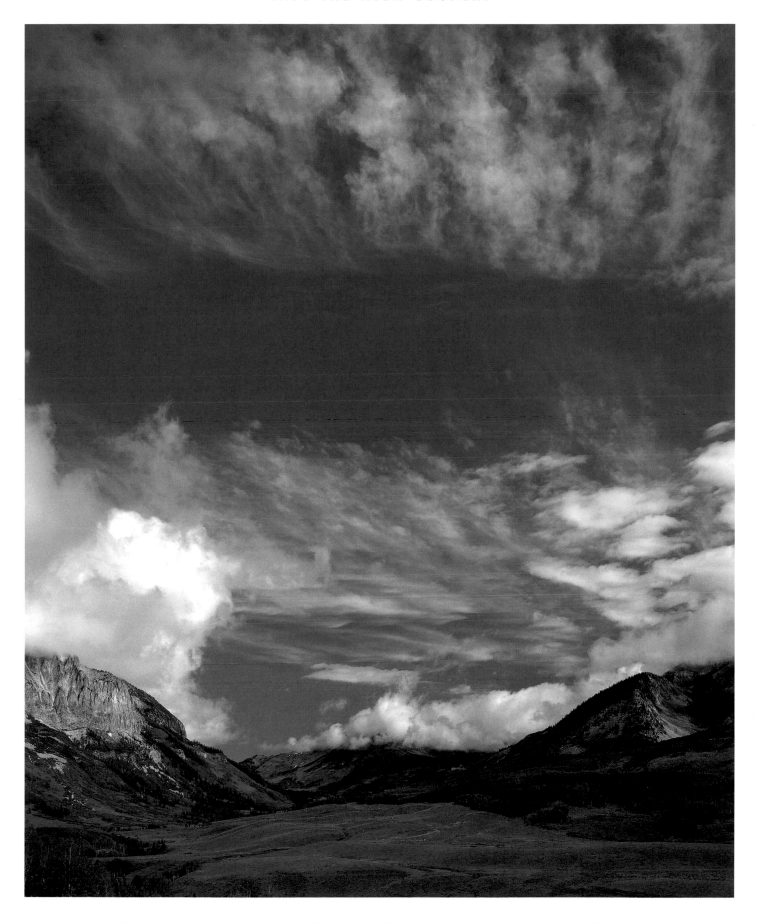

CLOUDS PAINT THE SKIES ABOVE SCHOFIELD PASS IN THE GUNNISON NATIONAL FOREST.

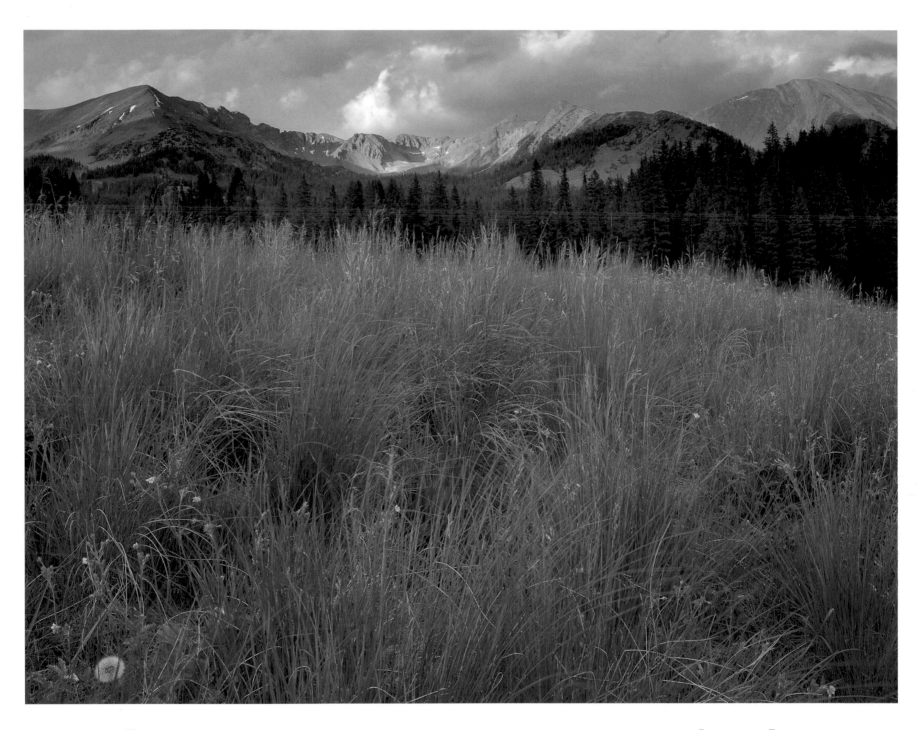

THE SUN'S LAST LIGHT SHINES THROUGH THE FAST-MOVING CLOUDS OF A CLEARING STORM NEAR SCHOFIELD PASS.

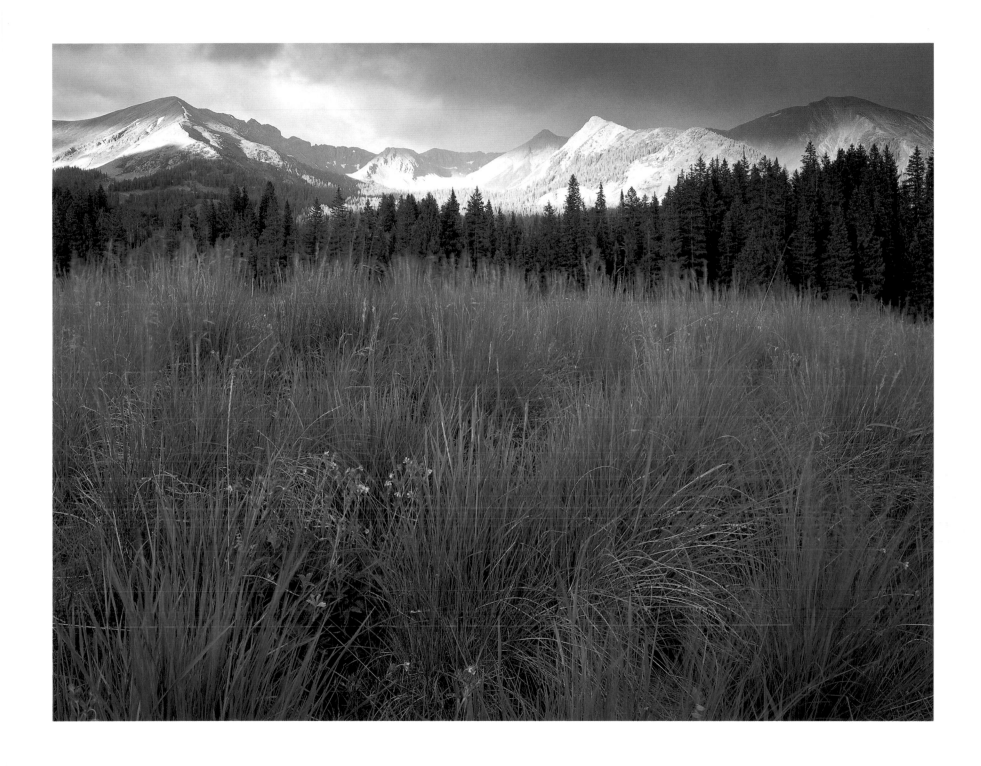

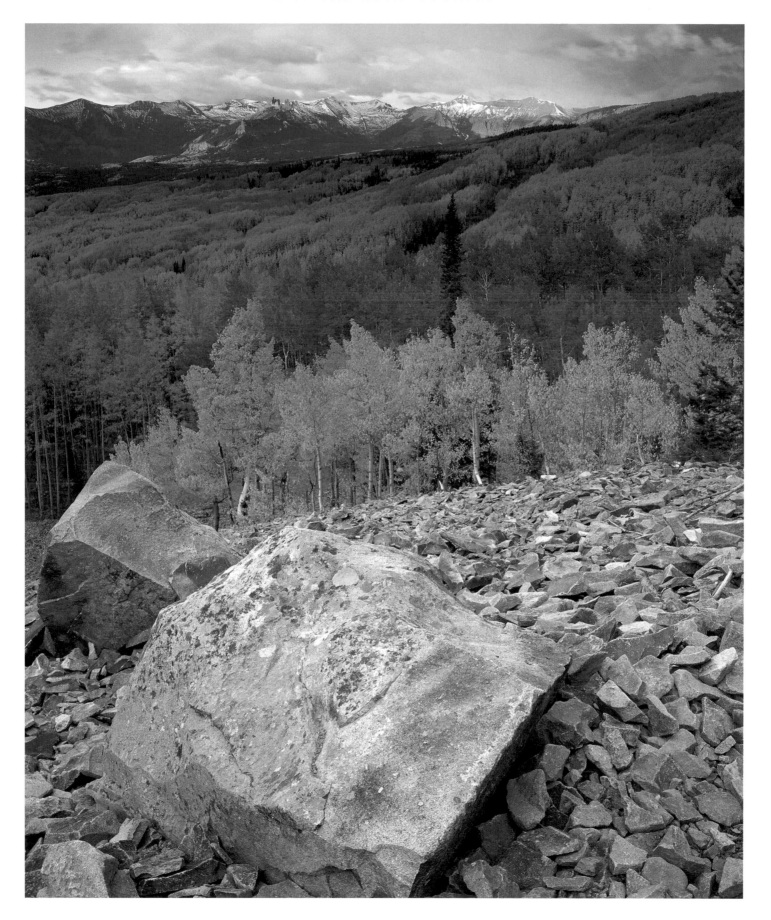

THE CASTLE MOUNTAINS STAND TALL OVER AN ASPEN FOREST IN GUNNISON NATIONAL FOREST.

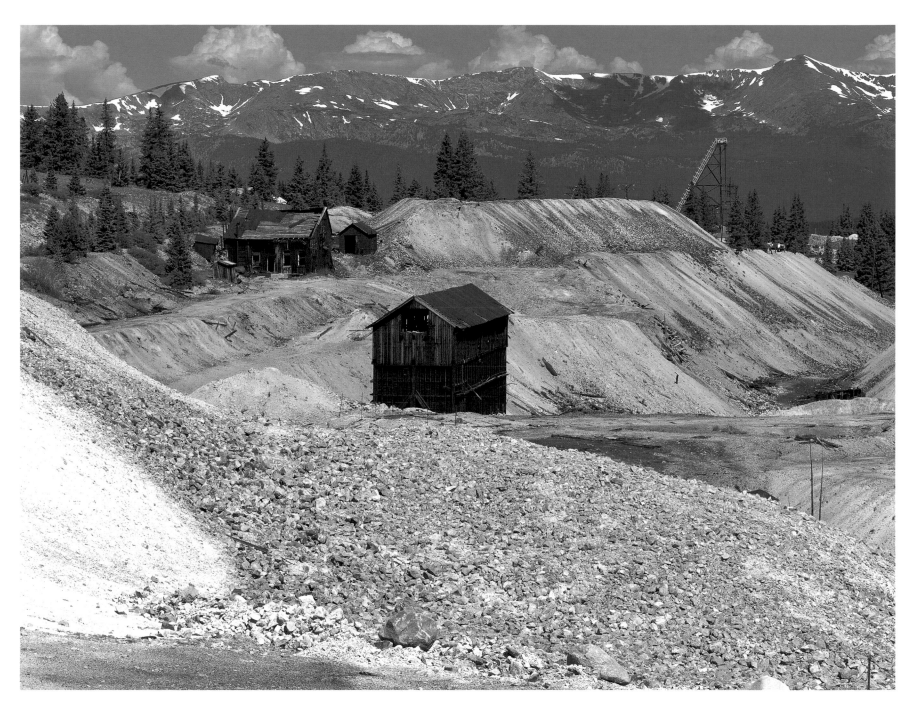

ABANDONED MINING BUILDINGS AMONG THE MINE TAILINGS AT LEADVILLE.

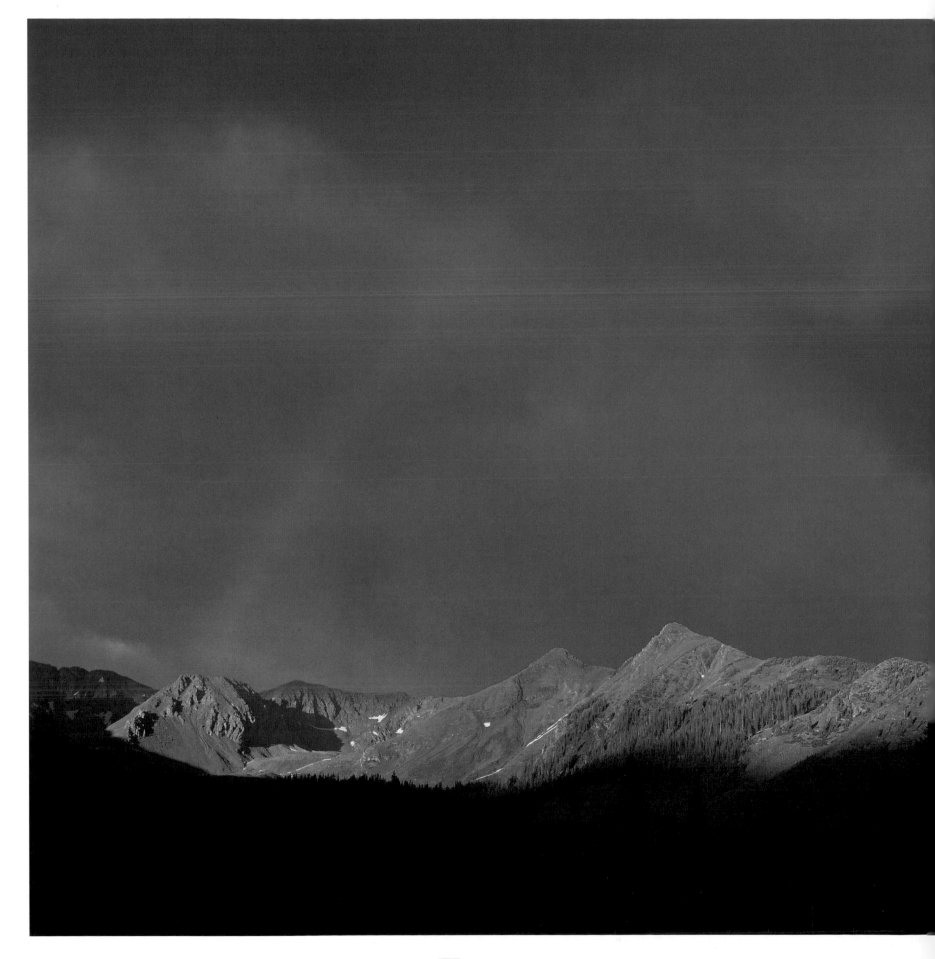

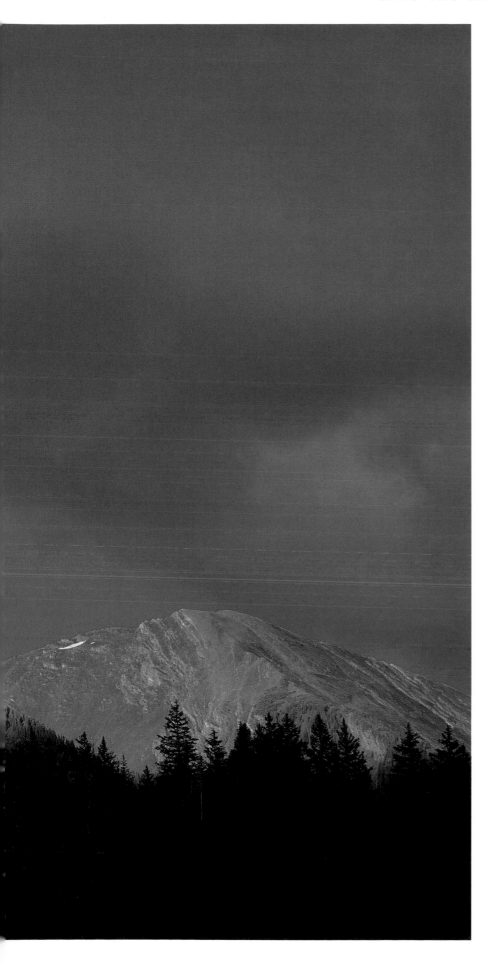

A RAINBOW SHINES IN THE SETTING SUN ABOVE THE PEAKS OF
GUNNISON NATIONAL FOREST.

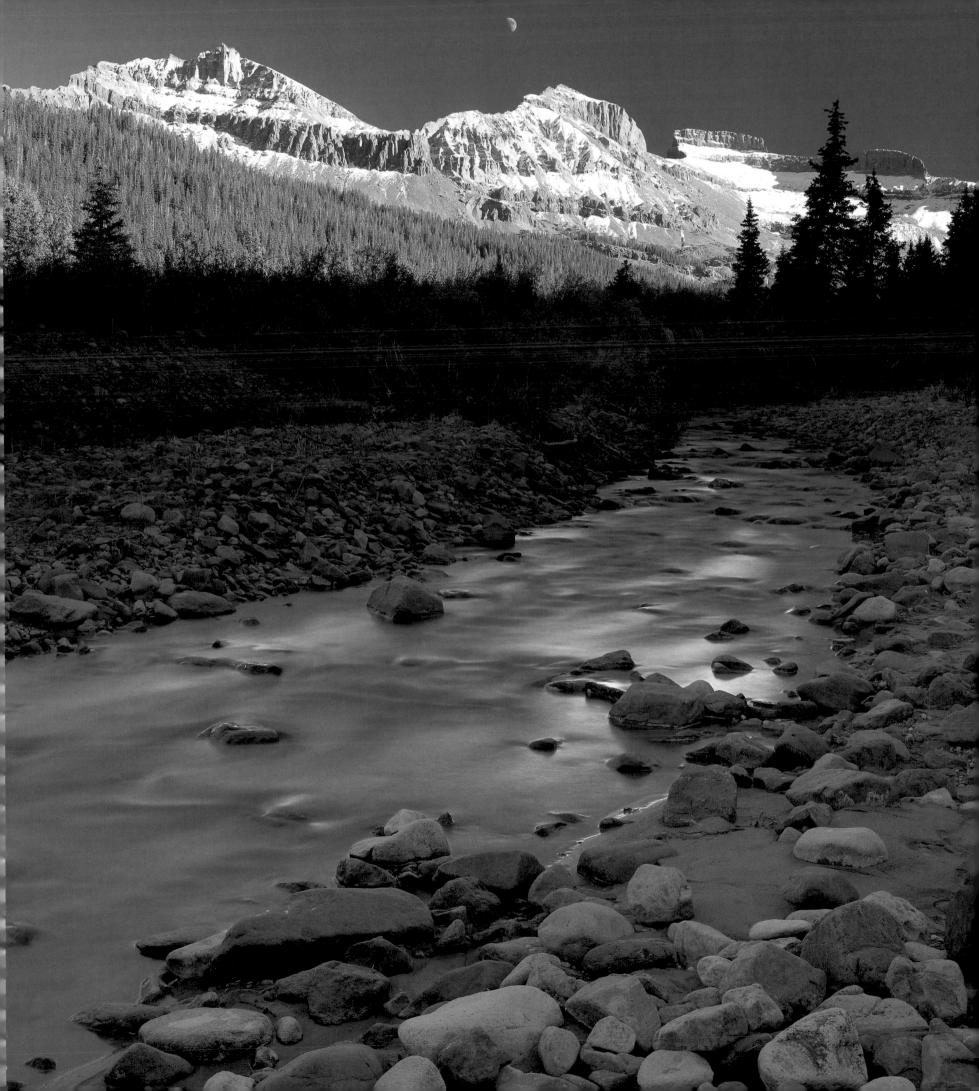

"The light died low in the clouds. Falling snow drank in the dusk. Shrouded in silence, the branches wrapped me in their peace. When the boundaries were erased, once again the wonder: that I exist."
—Dag Hammarskjöld

THE SAN JUANS

Range of Light and Beauty

The story of the San Juan Mountains is an epic of time and of people, of long-ago mountains worn down and of new ones rising, of powerful volcanoes like no human has ever witnessed, of torrential currents that sculpted cliffs and knifed through canyons. A tale of wind and rock, fire and ice. And it's a story of those First Americans who came to these mountains, traveling on silent feet over this range of beauty. Of Spanish explorers who left bits of themselves behind in the naming of peaks, valleys, and rivers. And, once again, of miners, the light of gold and silver in their eyes. And now it's a song of those who seek, in its profound loveliness, a spirit to enhance their own.

The landscape of the San Juans represents the quintessential high-country experience. Here, some of Colorado's most striking mountains silhouette against the sky—fourteen of the state's fifty-four peaks of more than 14,000 feet—standing in majestic, snow-topped splendor.

Sometimes referred to as America's Alps, the San Juans are a wonderland of glacial-carved valleys, steep forested slopes, and flower-strewn meadows. Water is abundant—in burbles and streams, in high mountain lakes, in fens and seeps, in natural hot springs, and in the first tracings of enormous rivers. Here the mighty Rio Grande, the third-longest river in North America, is conceived in high country snowfields. The Uncompahgre (a Ute Indian word meaning "red-rock canyon"), the Dolores, the Cimarron, and the San Juan are among at least a dozen other rivers, many still wild and untrammeled, that spring to life in the San Juans.

The first pioneers to venture into this high country millions of years ago were not the two-legged, human sort, but instead were plants—stalwart lichens, whose ability to create soil from rock over the millennia has paved the way for their more glamorous flowering descendants to follow. A relentless army, bent on destruction, lichen slowly forms a mat crust on the surface of rocks on talus slopes and in fell fields. When wet, they expand; when dry, they contract. This constant friction against the rock causes it to break down in minute particles, which, when mixed with decayed matter, turns into pockets of soil where other plants can take root.

Lichens are part algae and part fungus, growing only millimeters high. Forming fanciful mosaics of pattern and color—orange, black, bright chartreuse, and sage—they grip the rock, holding tight against high-altitude winds. There are many different varieties, and their names give clues to their appearance: crimpled, dog, flake, granite, jewel, pixie-cup, and snow lichens.

The most weather-resistant plant on earth, lichen has the chilly distinction of being the largest plant that grows on the continent of Antarctica. Thus, the task of surviving Colorado winters on wind-swept, rocky outcrops at 14,000 feet, buffeted by 100-mile-an-hour winds, in temperatures registering 50 degrees below zero, perhaps is not so difficult.

MOONRISE OVER THE WEST FORK OF THE CIMARRON RIVER.

REMAINS OF A GHOST-TOWN CABIN STAND STILL AT ANIMAS FORKS IN THE SAN JUAN RANGE.

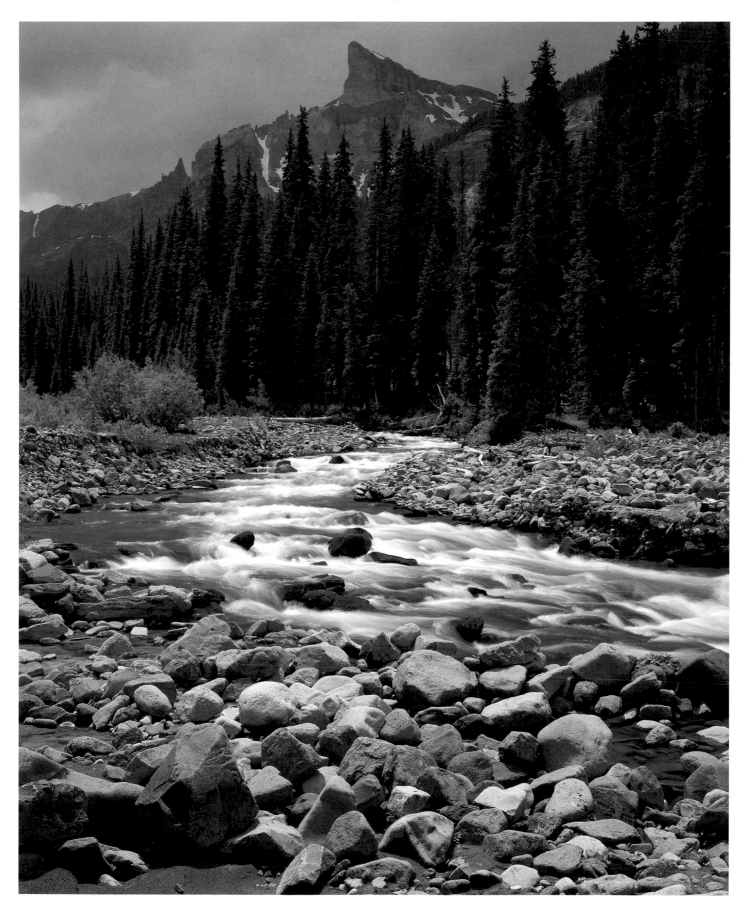

A SUMMER STORM STRIKES PRECIPICE PEAK ABOVE THE MIDDLE FORK OF THE CIMARRON RIVER.

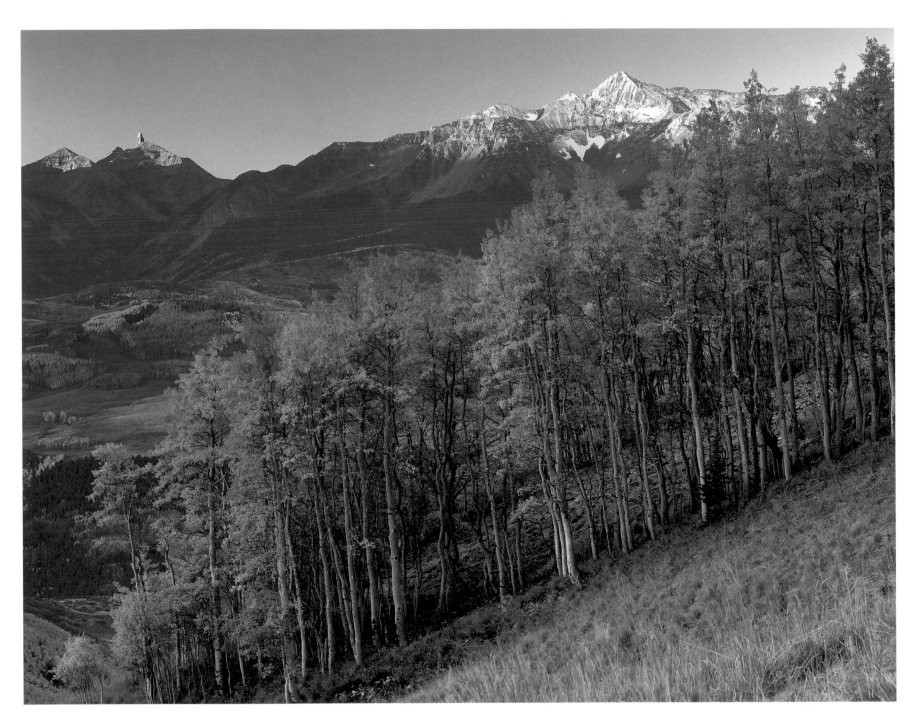

SUNRISE LIGHTS LIZARD HEAD PEAK IN THE UNCOMPAHGRE NATIONAL FOREST.

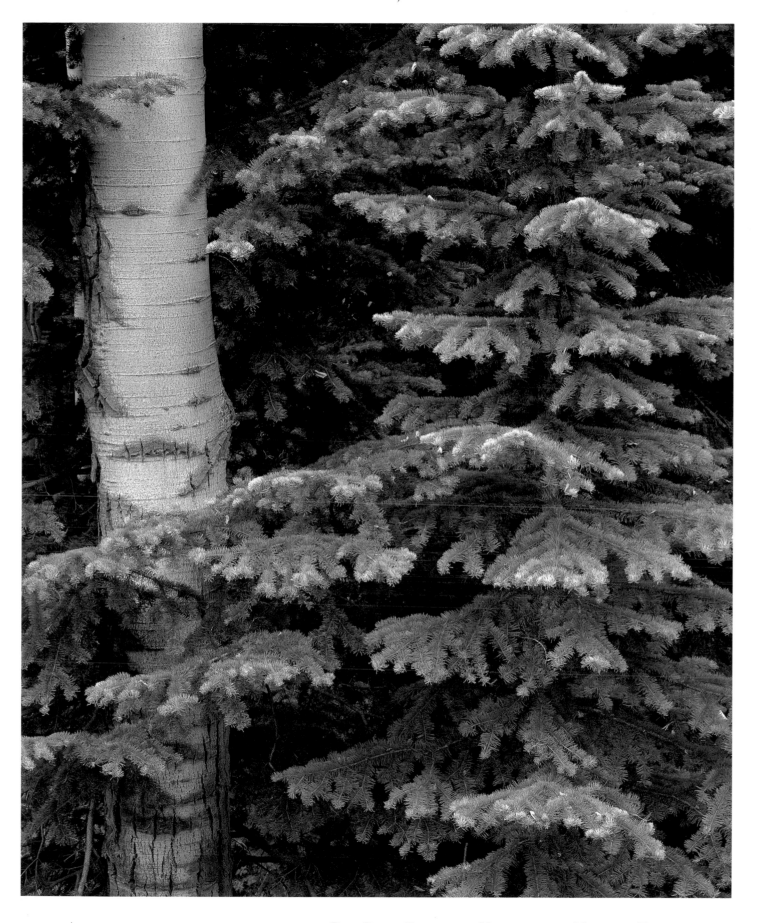

Aspen and fir trees grow side by side in Owl Creek Pass in the Uncompahgre National Forest.

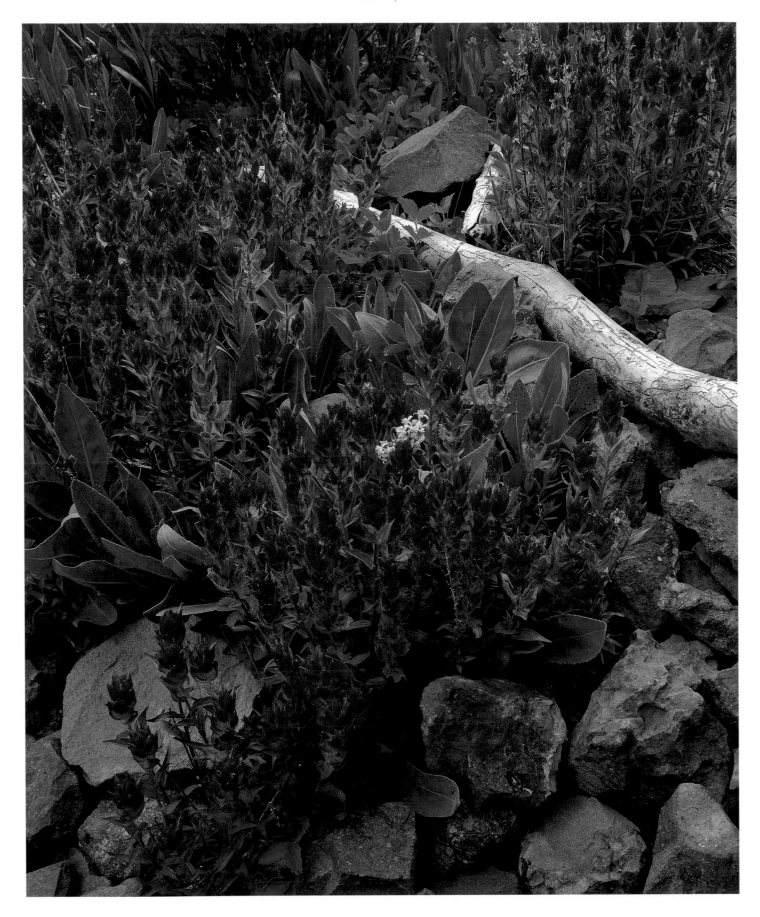

INDIAN PAINTBRUSH BLOSSOMS AMID LOGS AND ROCKS IN THE UNCOMPAHGRE NATIONAL FOREST.

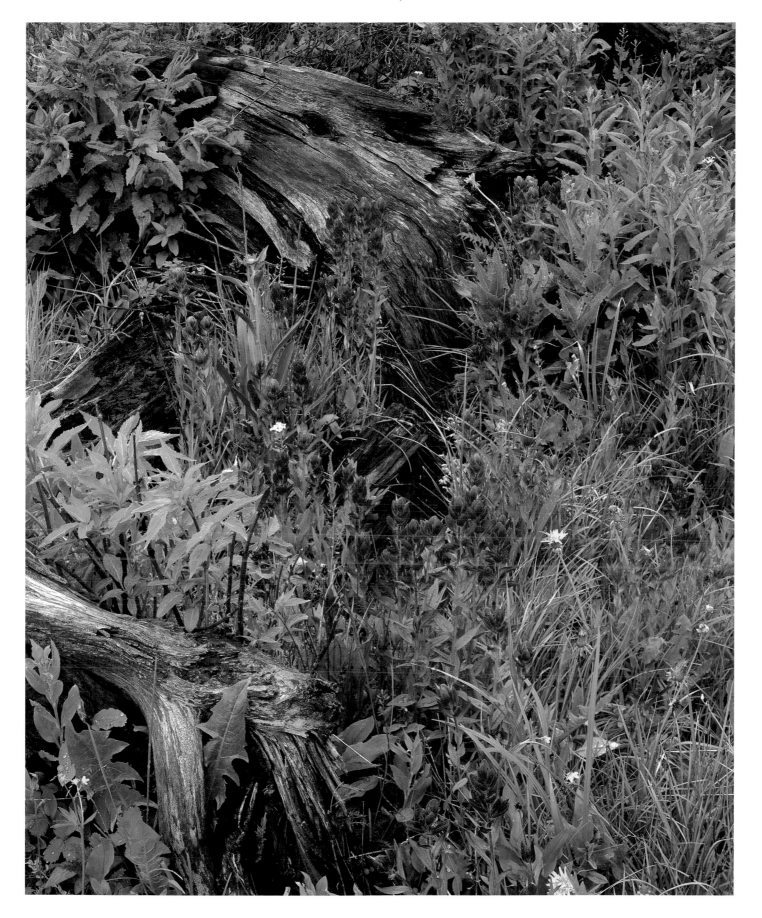

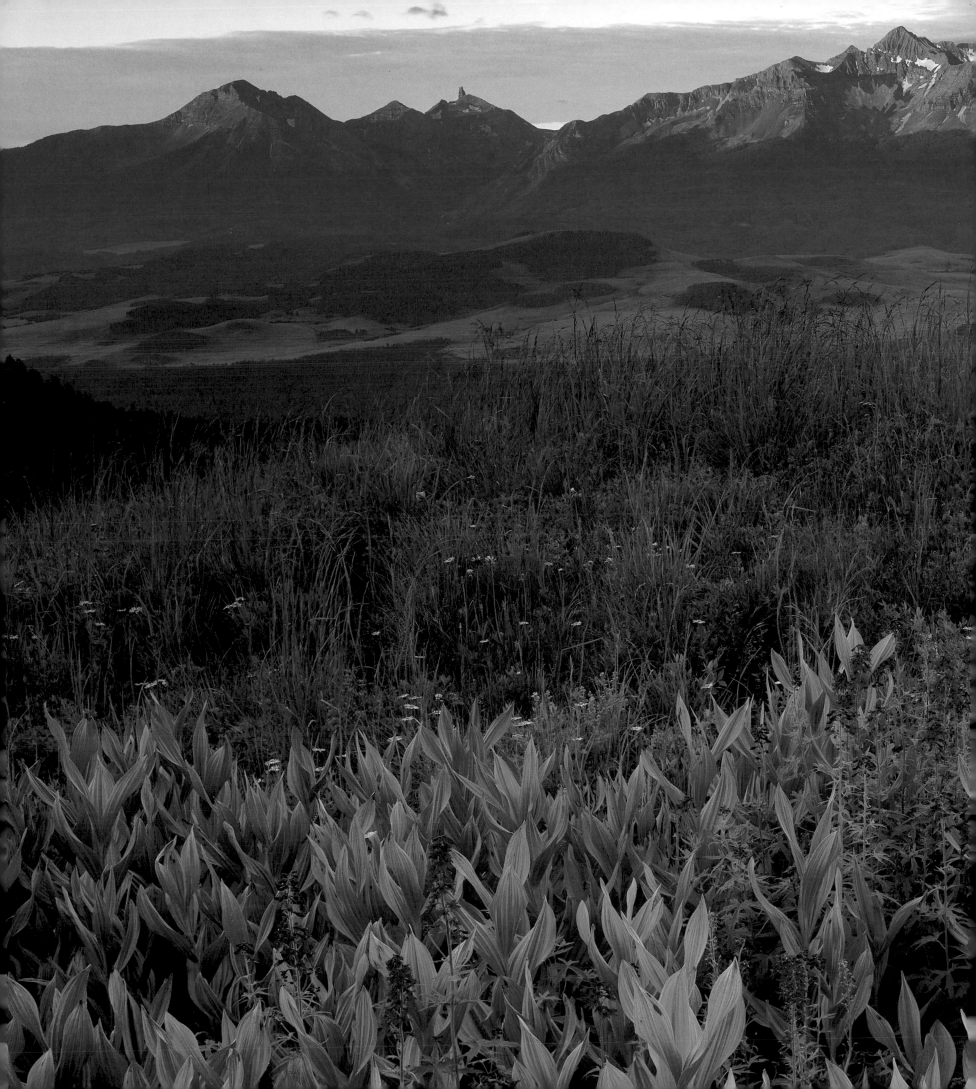

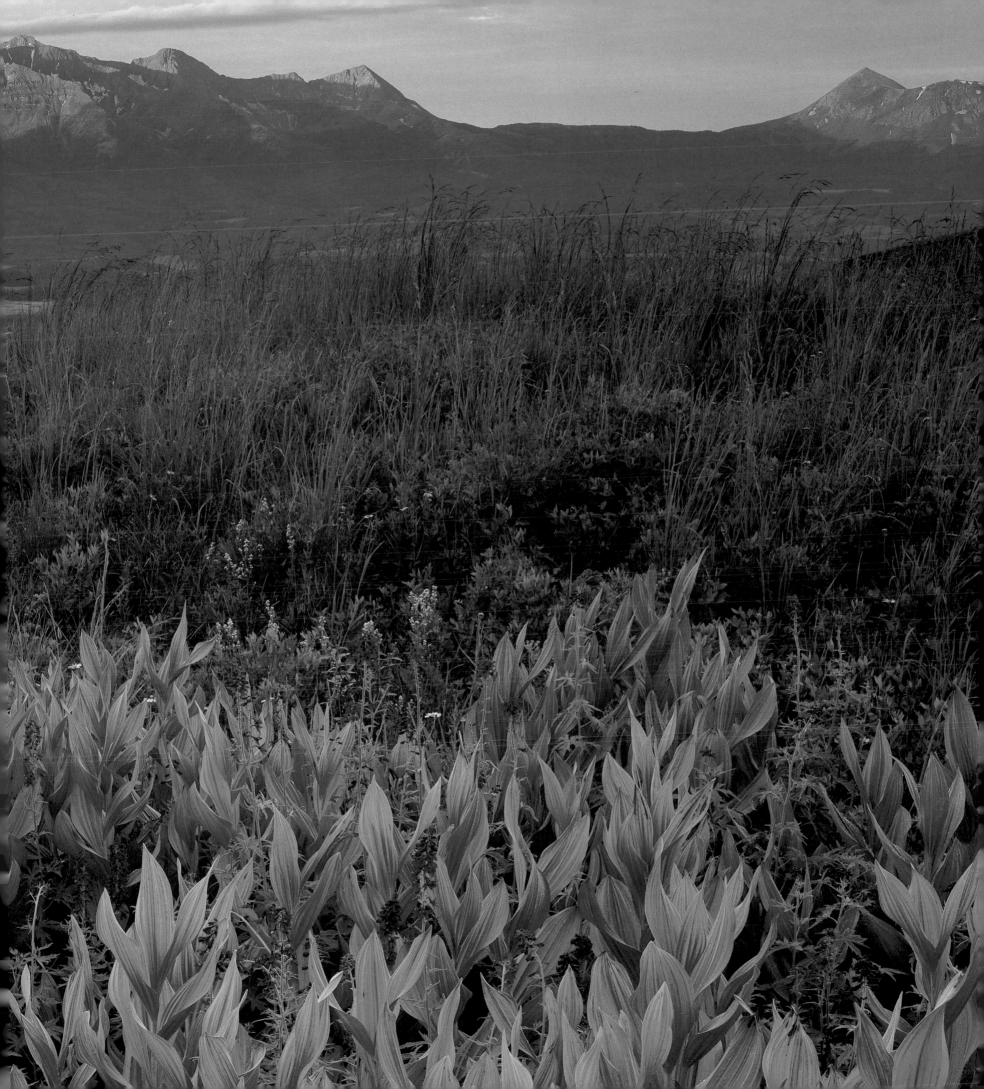

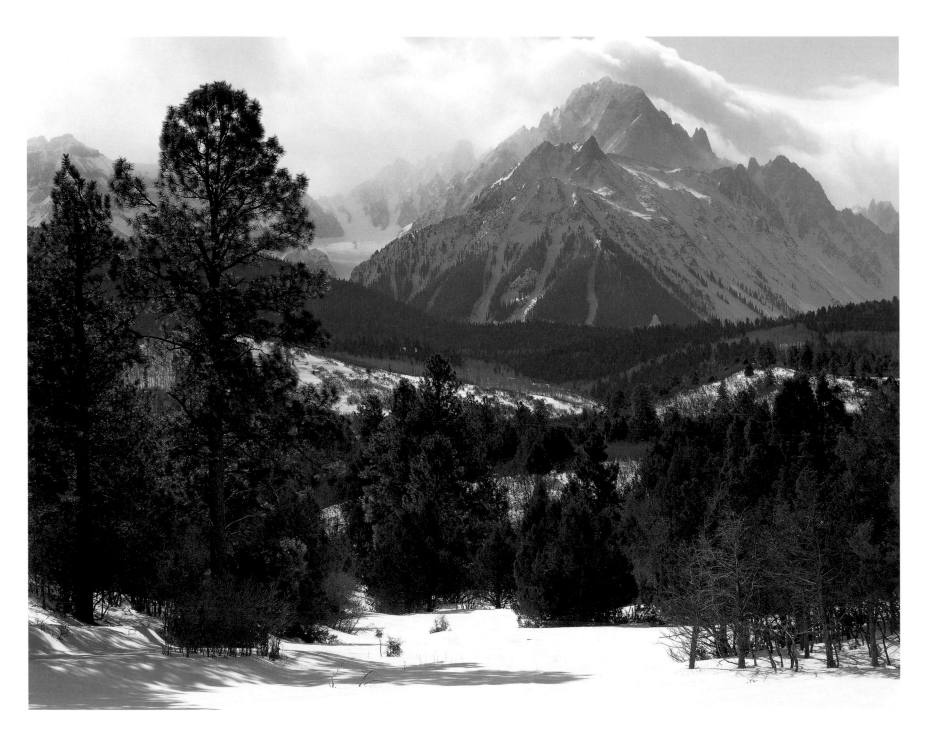

Snow blankets Mount Sneffels in the San Juan Range.

Previous pages: False hellebore and larkspur flower in an alpine meadow along Last Dollar Road below Mount Wilson.

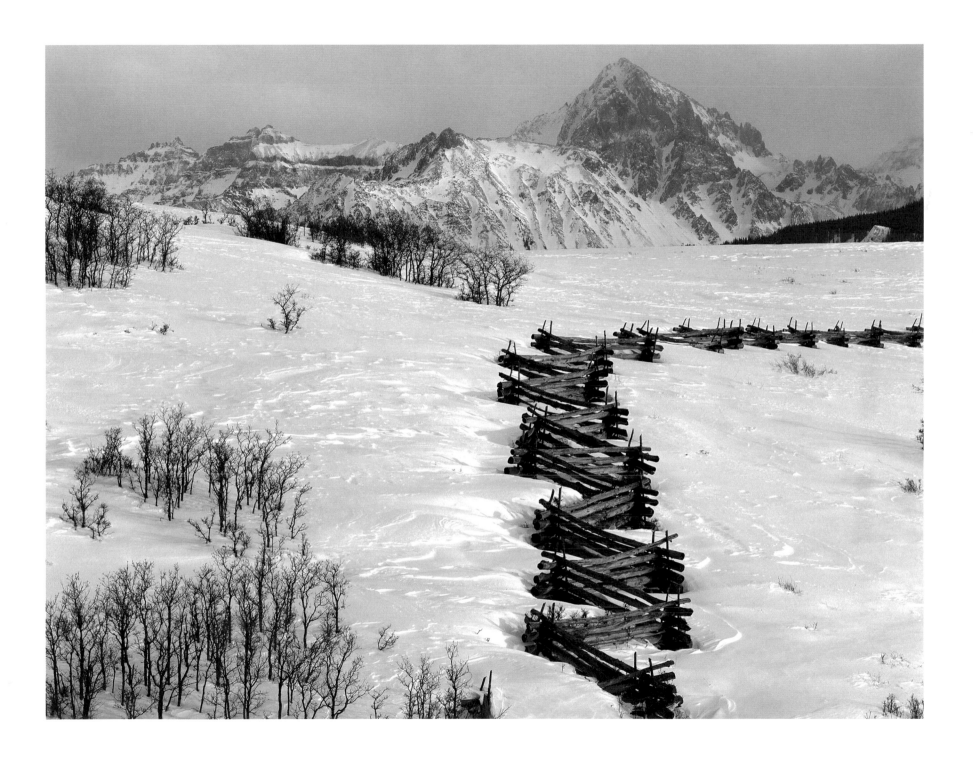

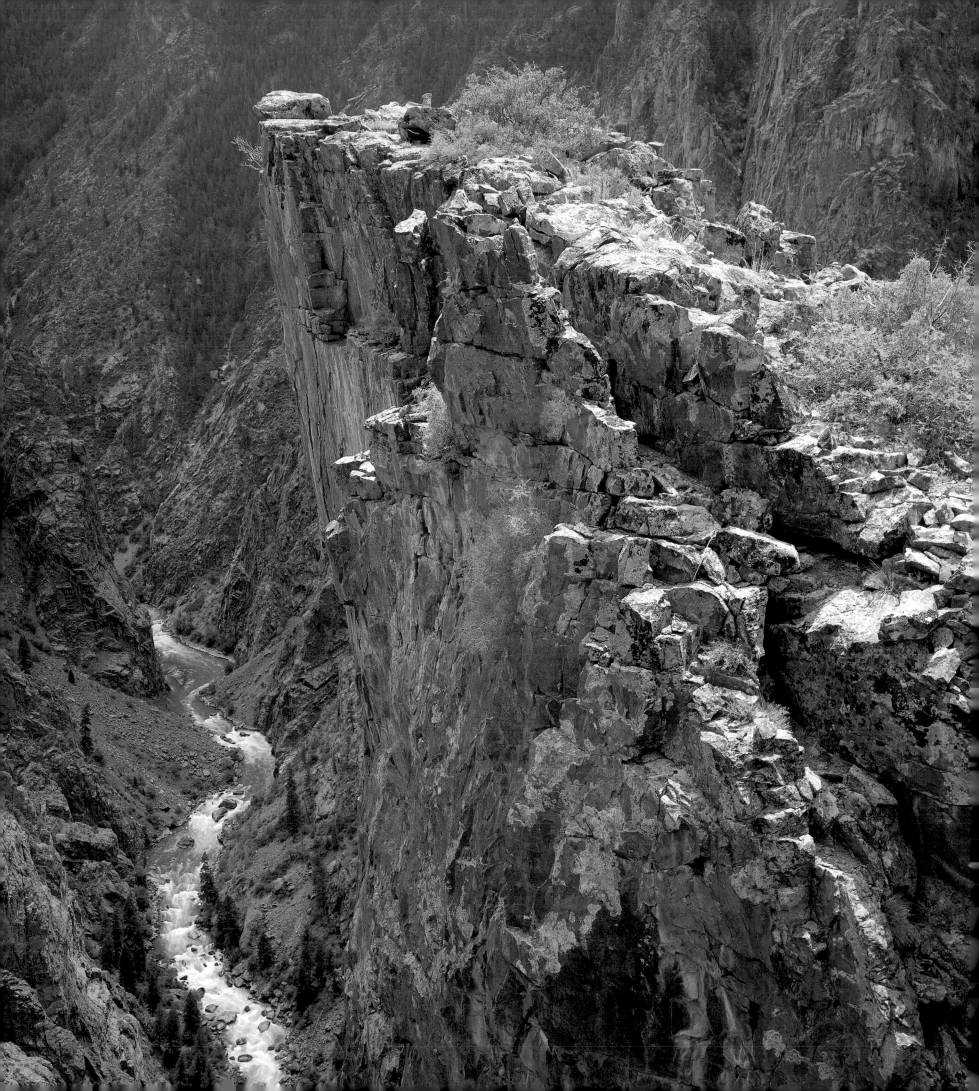

*"This is Coyote's country—a landscape of the imagination, where nothing is as it appears . . .
windows and arches ask you to recall what is no longer there, to taste the wind for the sandstone it
carried . . . for beauty is not found in the excessive, but in what is lean and spare and subtle."*
—Terry Tempest Williams, *Coyote's Canyon*

THE COLORADO PLATEAU

Unparalled Vistas and Subtle Beauty

Beyond the skyscraping peaks of central Colorado, westward to where the mountains give way to the desert, is a landscape designed with a penchant for extravagant contrasts and unfolding surprises. This is the Colorado Plateau Country, and here Mother Nature, over countless eons, has run amok.

Visiting this country is a geologic field day. This is a place of fantastically hued canyon walls and crenelated sandstone escarpments carved by patient winds with time as their only tool. Here, vast, pancake-flat plateaus form a grand staircase, linking the surrounding mountains to the grand valley below. And here dinosaurs, once again, lumbered along the sandy shoals of an ancient sea. It is a place of space and sky, sun and shadow, wind and rock, impenetrable stillness and endless horizons.

The Colorado Plateau encompasses parts of four states—Arizona, New Mexico, Utah, and Colorado—and is home to mind-blowing scenery: Grand Canyon, Bryce Canyon, Zion, and Canyonlands National Parks, and Monument Valley Navajo Tribal Park all lie within the Colorado Plateau. The Plateau arose as part of the same general uplift as the current-day Rockies that occurred some 60 million years ago. But instead of folding and fracturing as they did, the Plateau rose with far less upheaval, emerging more or less intact as one solid, enormous, contiguous land mass.

Mountains to the east and north blocked drainage off the Plateau, and an immense lake formed, a receptacle for silt flooding down from the Rockies and also for lava flows and ash from nearby volcanoes.

Further uplift caused the lake to retreat, leaving behind stacked, horizontal layers of differing types of sandstone, shale, and volcanic rock. Then the Colorado River and its many tributaries went to work. Assaulting the Plateau with their arsenal of weapons—wind, water, and time—they carved and sculpted canyons and mesas, exposing the underlying strata in the rock formations and revealing their dazzling array of colors.

Wind is the master craftsman of the Plateau, patient, determined, and unrelenting. Each type of sandstone responds differently to the wind. Depending upon its structure, some sandstone erodes

THE NARROWS OF THE GUNNISON RIVER VIEWED FROM THE NORTH RIM OF THE BLACK CANYON
OF THE GUNNISON NATIONAL PARK.

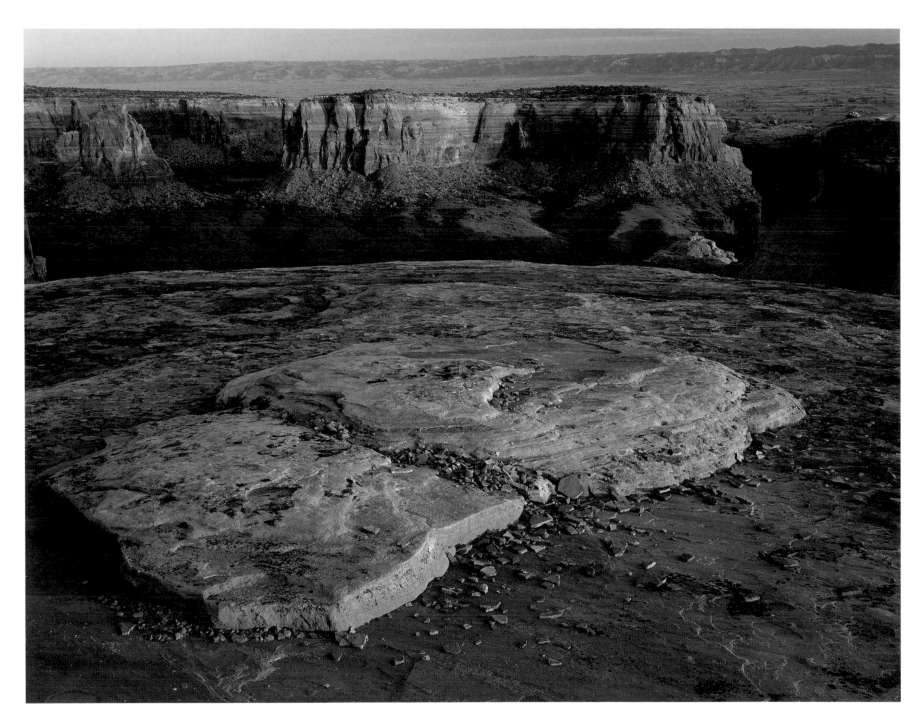

SUNRISE LIGHTS MONUMENT CANYON IN COLORADO NATIONAL MONUMENT.

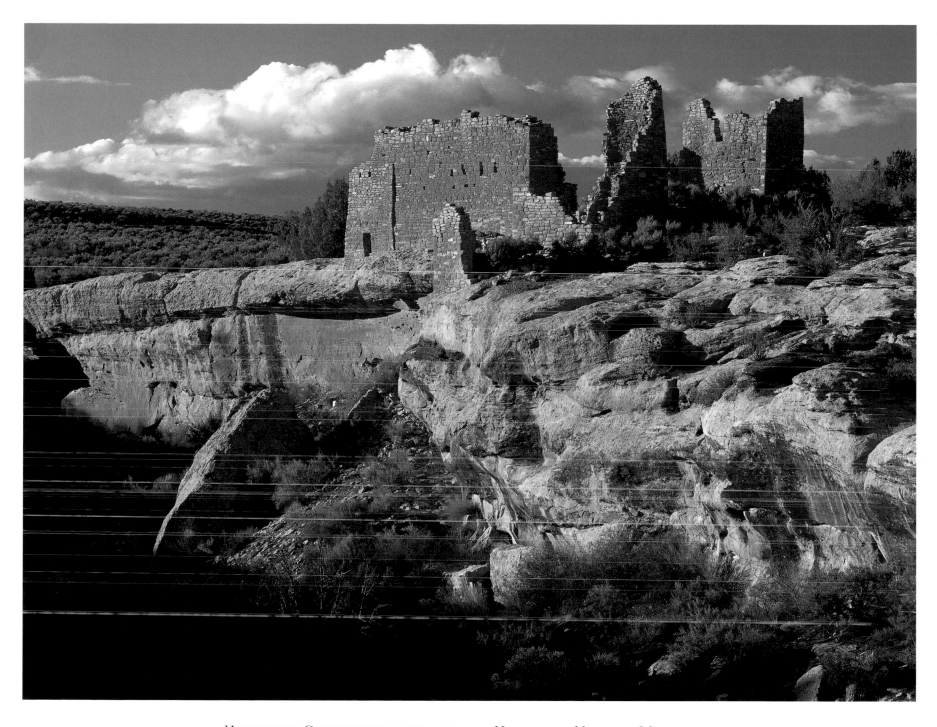

Hovenweep Castle rests atop a ridge in Hovenweep National Monument.

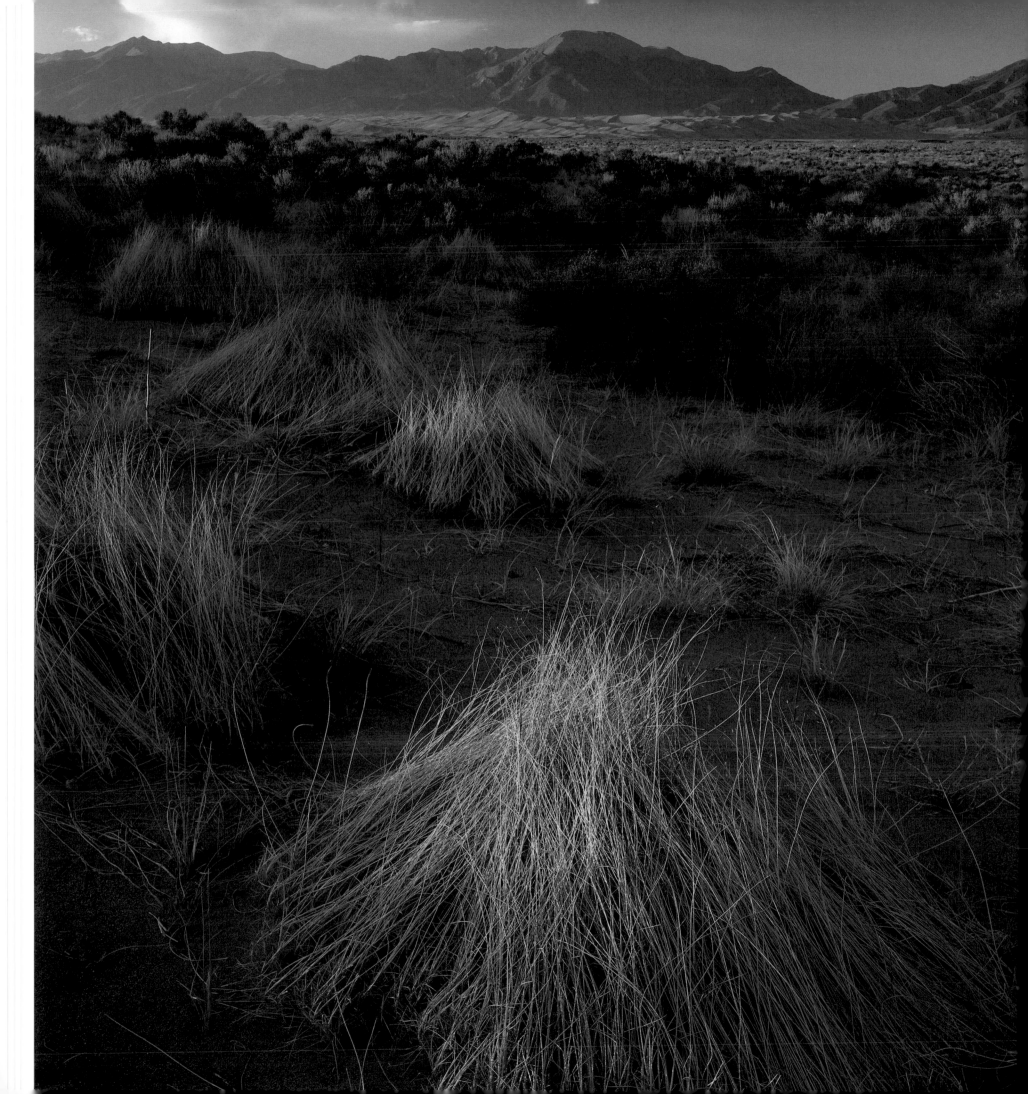

"But the beauty, the music, and life itself will go on beyond time only if man comes to understand the urgency of preserving the land, the water and the very air . . . only if he finds a way of correlating his needs with those of the universe will there be any time beyond now."
—Gwen Frostic, *Beyond Time*

COLORADO

Preserving the Spirit and Beauty of Our Land

The spirit of Colorado's land is mirrored in all who prize its wildness and seek its preservation. Its sublime mountains, sun-dazzled plains, rugged canyons, wildflower-splashed meadows, and crystalline waters have long inspired people from diverse walks of life to strive to preserve it—in words, on canvas, in song. And, in its most imperative sense, many have also sought—and continue to do so with singleminded purpose—*literally* to preserve and protect its incredible natural bounty in perpetuity. These are people who recognize Colorado's worth not in terms of timbers to be harvested or gold to be mined, but for the fundamental value of its unmatched beauty, whose properties both tangible and intangible must be guarded well and passed on, intact and inviolate, to generation following generation. These are, as the Nez Perce called such places, the *Heterwisnix Wetes*—the Precious Lands.

I'm standing on a grassy slope high above the relentless traffic plying the interstate between Colorado Springs and Denver. An endless stream of chrome and rubber, the corridor is searing evidence of the great pressures a burgeoning population has put on Colorado over the last dozen years. The two cities have moved ever closer together with an explosion of growth that has threatened to create nonstop suburbia between the two.

But from my vantage point, except for the freeway below, there are no signs at all of encroaching civilization. Instead, the unbroken vista extends through rolling hillsides punctuated only by stands of scrub oak trees. Beyond, like a benediction upon the land, the sun is setting behind the broad massif of Pikes Peak.

Unlike so many other areas around the state, this landscape has changed remarkably little since the days of the early settlers. Nor will it ever, for thanks to the realization of a dream shared by conservationists, a generous rancher, county commissioners, Colorado's governor, and most of all by its far-sighted citizens, 19,000 acres of magnificent landscape will remain so forever, untrammeled and intact.

The Conservation Fund, a nonprofit group dedicated to protecting open lands and natural heritage, spearheaded the efforts to preserve the Greenland Ranch. It is representative of a host of other conservation groups, private foundations, thoughtful individuals—natives and newcomers alike—and public representatives who work with passion and purpose to save in perpetuity the last and best of Colorado's amazing landscape.

There is plenty of work for all. In the fabulously beautiful East and Crystal River valleys between Crested Butte and Marble, the Trust for Public Lands is working to acquire private inholdings in the

THE SETTING SUN LIGHTS MOUNDS OF GRASS ON THE NATURE CONSERVANCY'S MEDANO-ZAPATA RANCH IN THE SAN LUIS VALLEY.

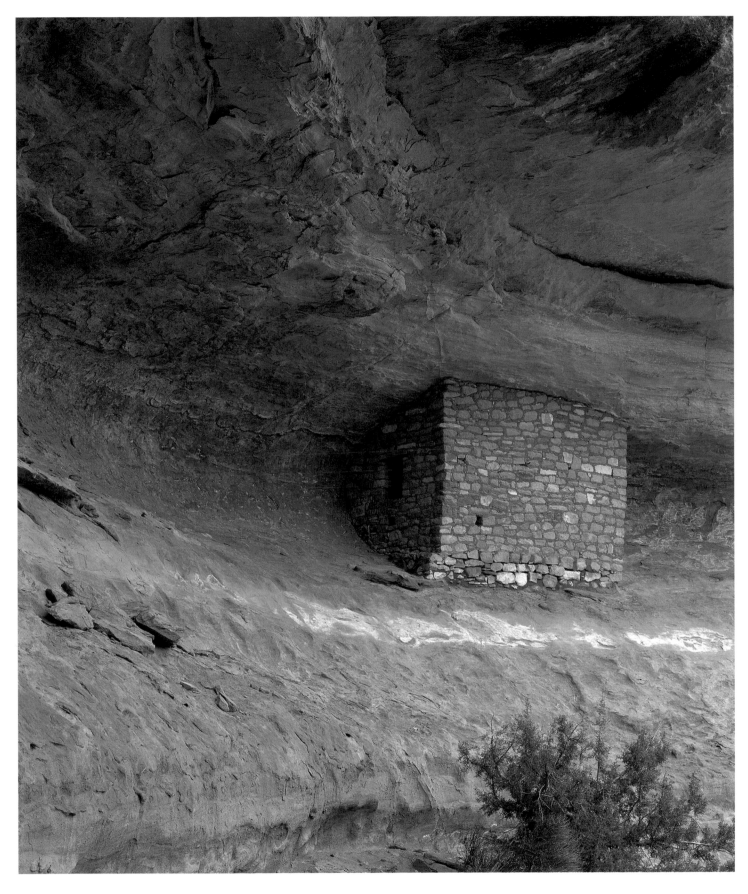

An Anasazi dwelling huddles within a cliff face in the Canyons of the Ancients National Monument.